WALK THIS WAY:
SIGN GRAPHICS NOW

Walk This Way: Sign Graphics Now
Copyright © 2010 by Collins Design and **maomao** publications

All rights reserved. No part of this book may be used or reproduced in any manner whatsoever, without
written permission except in the case of brief quotations embodied in critical articles and reviews.
For information, address Collins Design, 10 East 53rd Street, New York, NY 10022.

HarperCollins books may be purchased for educational,
business, or sales promotional use.
For information, please write: Special Markets Department,
HarperCollins*Publishers*, 10 East 53rd Street, New York, NY 10022.

First Edition:
Published by **maomao** publications in 2010
Via Laietana, 32, 4th fl, of. 104
08003 Barcelona, Spain
Tel.: +34 93 268 80 88
Fax: +34 93 317 42 08
mao@maomaopublications.com
www.maomaopublications.com

English language edition first published in 2010 by:
Collins Design
An Imprint of HarperCollins*Publishers*,
10 East 53rd Street
New York, NY 10022
Tel.: (212) 207-7000
Fax: (212) 207-7654
collinsdesign@harpercollins.com
www.harpercollins.com

Distributed throughout the world by:
HarperCollins*Publishers*
10 East 53rd Street
New York, NY 10022
Fax: (212) 207-7654

Publisher: Paco Asensio
Editorial Coordination: Anja Llorella Oriol
Editor & Texts: Matteo Cossu
Art Direction: Emma Termes Parera
Layout Design: Esperanza Escudero Pino
Cover Design: Emma Termes Parera

ISBN: 978-0-06-135322-2

Library of Congress Control Number: 2010924345

Printed in Spain
First Printing, 2010

WALK THIS WAY: SIGN GRAPHICS NOW

COLLINS DESIGN
An Imprint of HarperCollinsPublishers

CONTENTS

6	DIRECT DESIGN
8	CULTURAL CENTERS
78	INTERVIEW: FIRSTDESIGN
80	CORPORATE AND RETAIL
122	INTERVIEW: BÜRO NORTH
124	CIVIC AND HEALTH CARE
182	INTERVIEW: BÜRO UEBELE
184	PUBLIC SPACES
226	INTERVIEW: DETAIL
228	THE FUTURE OF SIGNAGE
254	INTERVIEW: STUDIO DANIELA BIANKA

DIRECT DESIGN

This book addresses signage and wayfinding through the curious eyes of a viewer who wants to explore not only the aesthetic side of the projects, but also the functional ones. Projects were chosen in two stages: We looked first at paramount and innovative signage systems. We then narrowed these selections to a group of extraordinarily successful designs that represent advancements in their niche and, most importantly, were deemed extremely functional and well suited to their environments. All good signage projects add value to the premises where they are implemented; they should enhance visitor experiences, ease fruition of the spaces, or have a decorative essence. Ideally, all three.

The studios featured in *Walk This Way* were asked to submit their best and most representative work, making this book made by designers for designers—with a great emphasis on visuals. Nonetheless, text is by no means of secondary importance: by means of detailed descriptions and informative interviews, we were able to incorporate just the right amount of text in order to give valuable insights regarding the conception of the projects, the materials used, and the decisions regarding sign placement.

A badly designed sign is worse than no sign at all!
Quality and functionality are intricately linked in the overall success of a signage project. Indeed, these two aspects are fundamental in any aspect of a design application; however, considering the unique purpose of a sign, a badly implemented project can risk self-sabotage. Common problems arise from two main areas: the lack of proper prior research on visitor usage of the site and the lack of integration of the sign with the space's architecture.
Case in point: A new business installment opens its doors to the public with a poor wayfinding strategy and, consequently, poorly placed signage. Before long, the administration starts receiving complaints from visitors and/or repeated questions on where to direct themselves to find this or that office. Big problem. But looking on the bright side, these circumstances are often the spark for management to understand the importance of good sign design. An informed design firm will use the complaints and implement a solution based on these experiences.

Depending on the location of the building the sign will be featured in, its size and the demographics of its visitors, research can be more or less detailed. Common denominators designers need to know are: frequent guest destinations in the building and average time spent in the main rooms of the building. This information will allow them to determine the best means of navigating the structure and the most visitor-friendly paths within it. Given a limited time frame, designers may be tempted to create a sign based on their own suspicions of how visitors think or what they assume the easiest way to navigate a building is, but research is critical. Effective sign placement is a direct consequence of studies and consultation with the building's staff. Without research, signs frequently lack functionality no matter how aesthetically pleasing they may be. A street sign is useless if placed behind a tree.

DIRECT DESIGN

Sign design can be seen as the visual interface—to use an information technology term—of the buildings to which it is applied. Weirdly enough, graphics and architecture can be seen as a difficult pair to combine, and on paper they are. While most architects in referring to their work use keywords such as "theoretical," "abstract," or "commotion," sign designers prefer more down-to-earth terms such as "tactile," "user experience," or "eye-pleasing." The goal of visual interface is to make one follow the other to the point where integration of both architectural and design concerns is seamless. In the projects featured here, they represent two indiscernible layers.

An interesting generalization can be made by giving a quick glance at the ensemble of projects and from the studio interviews at the end of each chapter: All studios keep in high regard not only their clients' directions and their own aesthetic and functional standards, but also the architect's initial intentions. To explore this in more detail, we can look at the outstanding signage system of the Aomori Museum of Art, for example. While conversing with Tilmann S. Wendelstein, a senior designer responsible for the project, on the interplay between their system and Jun Aoki's project for the museum building, expressions like "harmony with the architecture" and a "close trust in each other's abilities" were used. Wayfinding and signage designers see the actual space and structures where they implement their work as canvases, yes, but even more so as inspirations.

Sign design can be seen as the frame that "makes" places, that delimits the spaces and gives a comprehensible dimension to objects. The mediation between the user and the space happens through design; it's how users interact with the environment. Arrows, instruction booths, maps, and entrance labels set up conditions in which the wayfinding experience is carried out. This complex process, which is at the base of how users perceive the entire visiting experience, is more visual than verbal. Although we have tried to stress where possible the practice of custom font design and described the reasons behind the typographic choices made for some signs, this trend is clear. A reason can be sought in the increasing globalization of big cities and the need for signage that can be "read" and understood immediately.

Sign design is almost never a task left to inexperienced design firms. Most companies or studios that excel in this practice are medium to fairly large. The reason lies in the difficulty of developing a sign strategy as an independent endeavor. Almost always, it is a multifaceted matter involving many different teams, including architects, designers, and manufacturers. Everyone chips in to implement a graphic framing, which is essentially a finishing touch, a fine-tuning that coats thinly yet gives a reading key to the space it defines, dramatically changing the installment's interaction with its users and the environment.

CULTURAL CENTERS

This chapter deals with projects related to cultural installations such as museums, national landmarks, libraries, cinemas, and theaters. We chose this as the first and most representative chapter for the heterogeneous nature of the projects it includes. For obvious reasons, the cultural sector has always been the most rewarding and creatively free for designers in all disciplines. Implementing a signage or wayfinding strategy in this sector has always been driven by function. Nevertheless, particularly in this chapter, all studios have managed to find ways to combine efficient strategies with original and innovative elements. This has been achieved either by playing with form, or less conventionally, by experimenting with new materials and new techniques and cross-pollinating with different disciplines. The signage implemented at the Aomori Museum of Art is a prime example of a comprehensive sign strategy putting into practice what it preaches: new materials, a custom typeface, and made-to-order pictograms. Attention to detail exemplifies what is needed to stand out from the crowd.

10 AOMORI MUSEUM OF ART

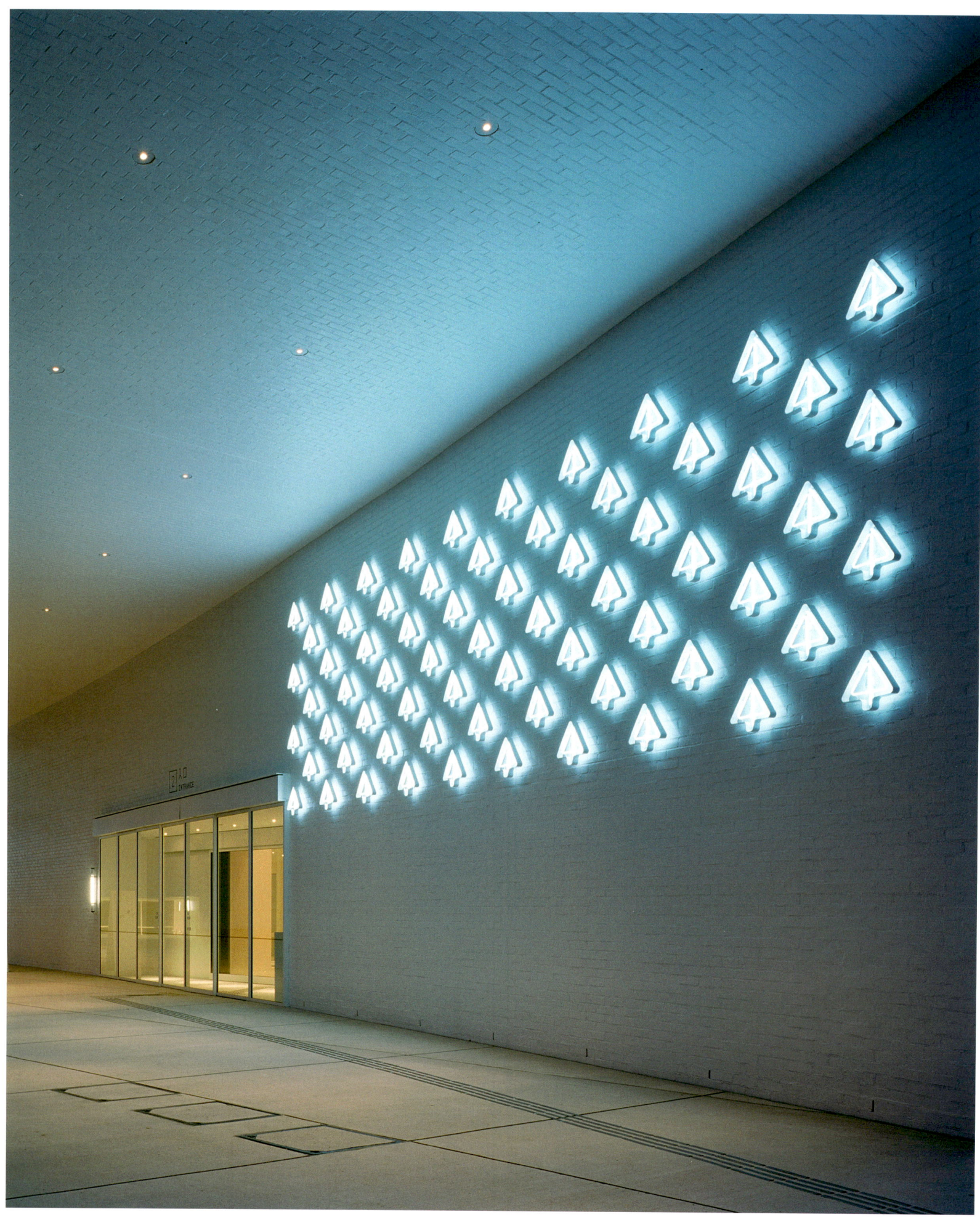

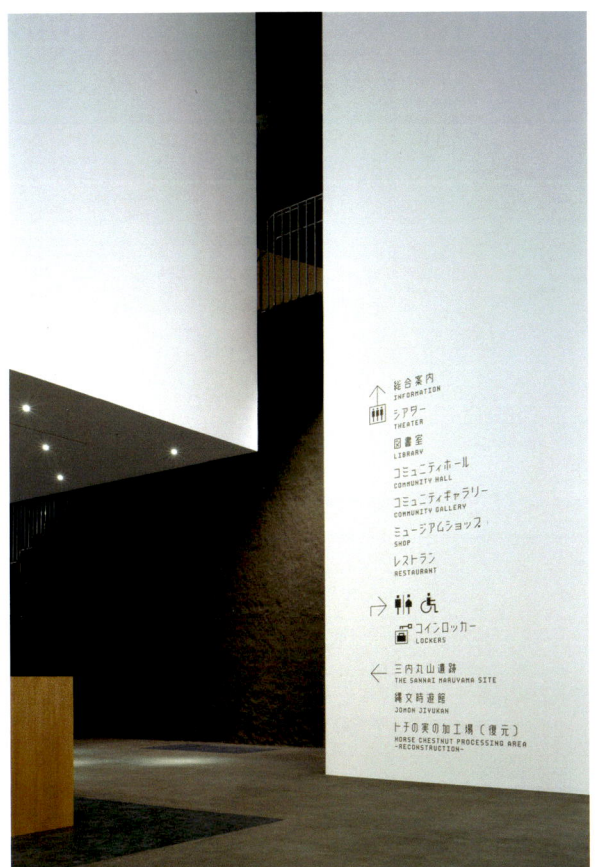

AOMORI MUSEUM OF ART

This building is located outside the city of Aomori, Japan, close to an archaeological excavation site. Its proximity to the site inspired its architecture and combines a white cube concept with rough earthen walls. The overall branding—from the logo to the signage—was designed in close consultation with the architect Jun Aoki, whose main focus was the interplay of structure and nature. Thus the approach was to let the design appear rough, but functional at the same time. Besides a conventional decorative use, neon logos were placed on the walls around the exits to indicate those points of ingress and egress.

Location: Aomori, Japan
Design team: Atsuki Kikuchi, Shoichiro Moriya, Tilmann S. Wendelstein, Shinji Nemoto/Bluemark
Website: www.bluemark.co.jp
Main materials: concrete, metal and bricks, neon lighting

>>>

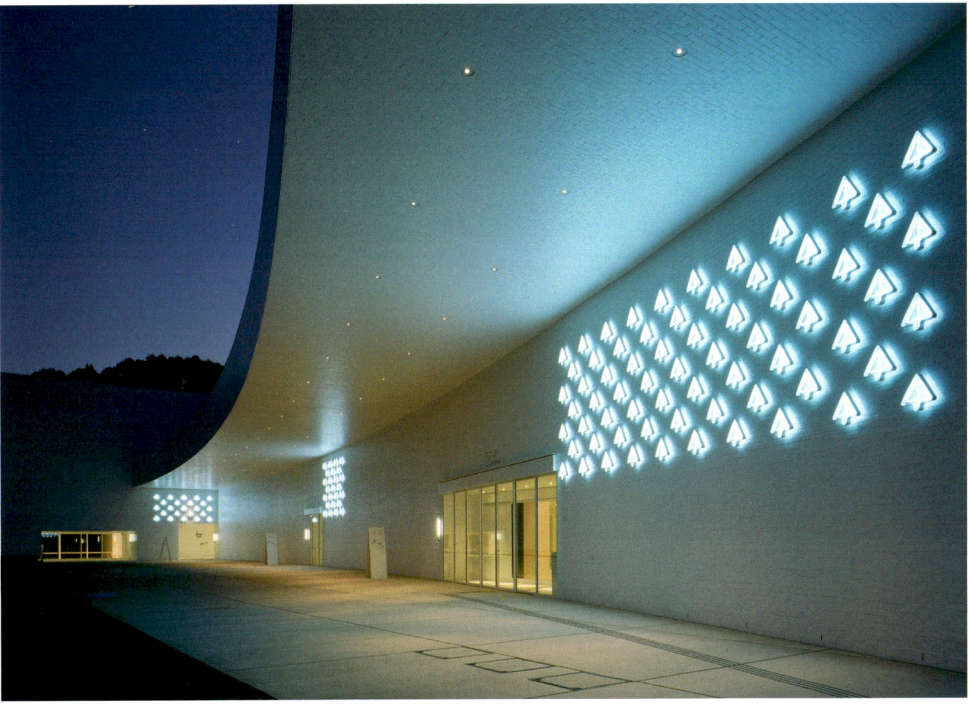

AOMORI MUSEUM OF ART

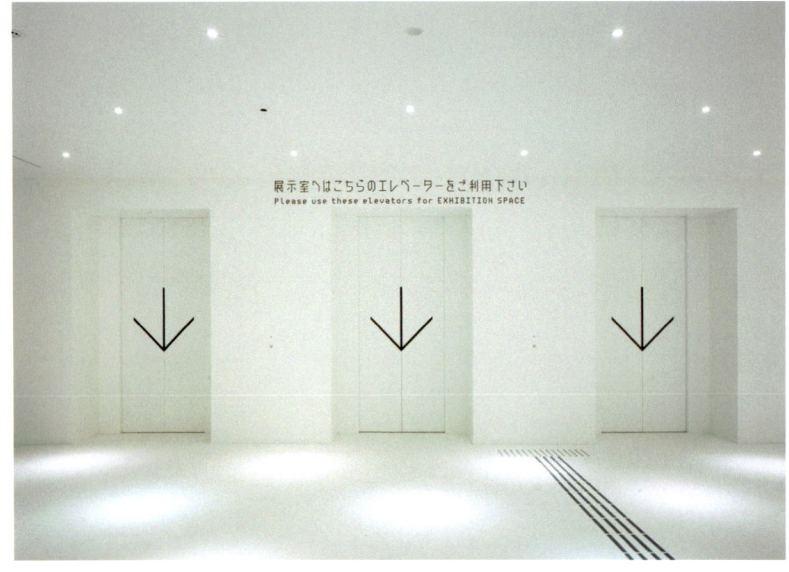

In this project, everything from the biggest sign to the single sign letter was constructed within the same simple grid of verticals, horizontals, and 45-degree angles. The earthy, rough texture of the brick walls was a perfect background for the Aomori typeface, contrasting with its stark lines. To assure quality on the uneven surface, the signs were individually inspected and stabilized.

<<<

AOMORI MUSEUM OF ART 13

Neon lights were strategically placed to aid legibility of the signs. All letters, Latin and Japanese (Katakana, Hiragana, and Kanji), were exclusively designed for this signage and applied to almost every written word inside and outside the museum. Screen-printed metal plates were used when the signs weren't applied directly on the walls. Pictogram design was kept in line with a grid principle.

>>>

AOMORI MUSEUM OF ART

Aomori Regular_kanji

安暗案以位意遺一員引運営映閲円煙遠応押屋下
化加家火荷課貨過画会械開階外概角学活環管観
間関館丸願企危器基期機帰気記起議却休救給許
恐響業禁近金係型憩経計警月建県見鍵険験元厳
源限庫故後御護功口工控校硬行講降高合国座最
載剤作察三傘参山散使志指止視試事持時示自室
実写者車主取手受授収拾週集従重出術準順所署
署書諸女小昇照障上乗場常状職森身尋図水数制
昭消清生青席石積責跡接設専栓施前素創倉掃操
総装送像蔵側神体対貸退大第谷端段地置築室中
注駐貯調長直通定展転点電途土投棟盗湯灯当等

Aomori Regular_hiragana

あいうえおかきくけこさしすせそたちつてとなにぬねの
はひふへほまみむめもやゆよらりるれろわをん

A single design was chosen for the Aomori typeface. This helps museum signage in two ways: it standardizes room and label numbers to a fixed length, and it homogenizes the look of the writings both in English and Japanese. It was of fundamental importance to give the impression of uniformity throughout the type signage.

<<<

AOMORI MUSEUM OF ART 15

Aomori Condensed Bold_alphabet

ABCDEFGHIJKLMNOPQRSTUVWXYZ
abcdefghijklmnopqrstuvwxyz
1234567890.,/--!?;:'()

Aomori Condensed Regular_alphabet

ABCDEFGHIJKLMNOPQRSTUVWXYZ
abcdefghijklmnopqrstuvwxyz
1234567890.,/--!?;:'()

Aomori Pictogram

Aomori Directionmark

16 BRONX LIBRARY CENTER

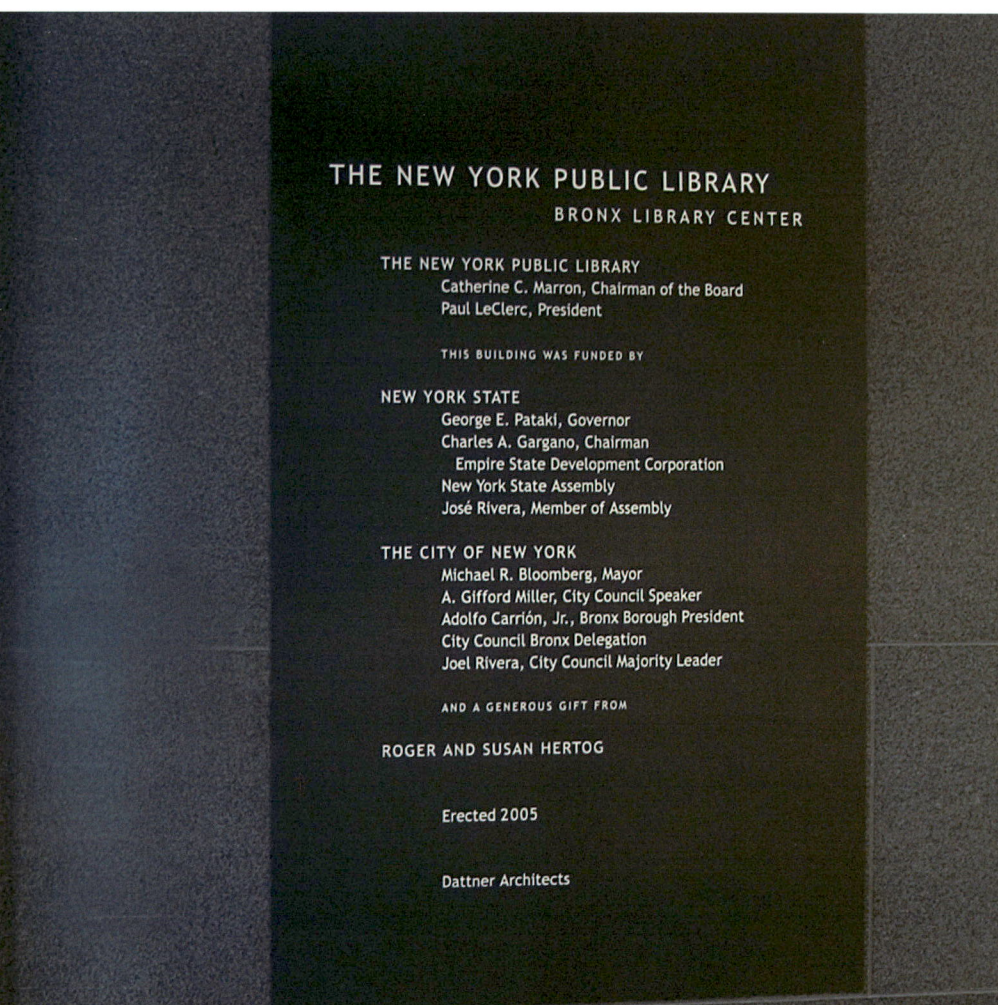

BRONX LIBRARY CENTER 17

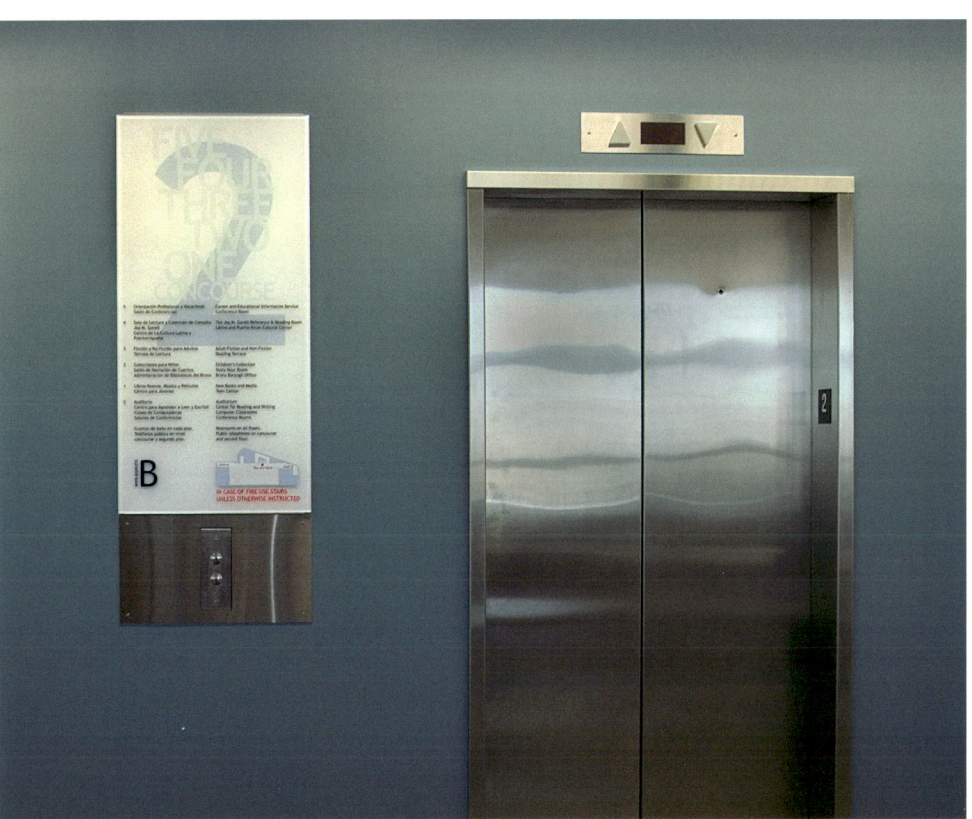

BRONX LIBRARY CENTER

The largest public library in the Bronx carries extensive collections of print and non-print materials for adults, young adults, and children. It also features the New York Public Library's premier Latin and Puerto Rican Heritage Collection. An intensely varied visitor base (adults, teenagers, children, and nonnative English speakers) called for a complex signage system to cover its 75,000-square-foot premises. Keeping in mind that this $50 million state-of-the-art building is also NYPL's first green library, the sign production also kept to high ecological standards.

Location: New York, N.Y., United States
Design team: Wojciechowski Design
Website: www.designw.biz
Main materials: plastic

>>>

18 BRONX LIBRARY CENTER

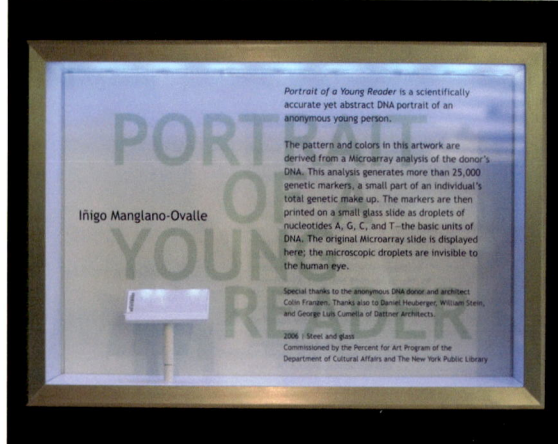

Low-glare glass directories have etched copy in English and Spanish; background lettering is screen-printed on the second surface. Floor directories contain layered information without losing clarity of hierarchy. The color scheme is subdued with the clean, modern architecture. The biggest signs are made with an opaque treatment of recycled plastic to respect green standards and contain costs.

<<<

BRONX LIBRARY CENTER 19

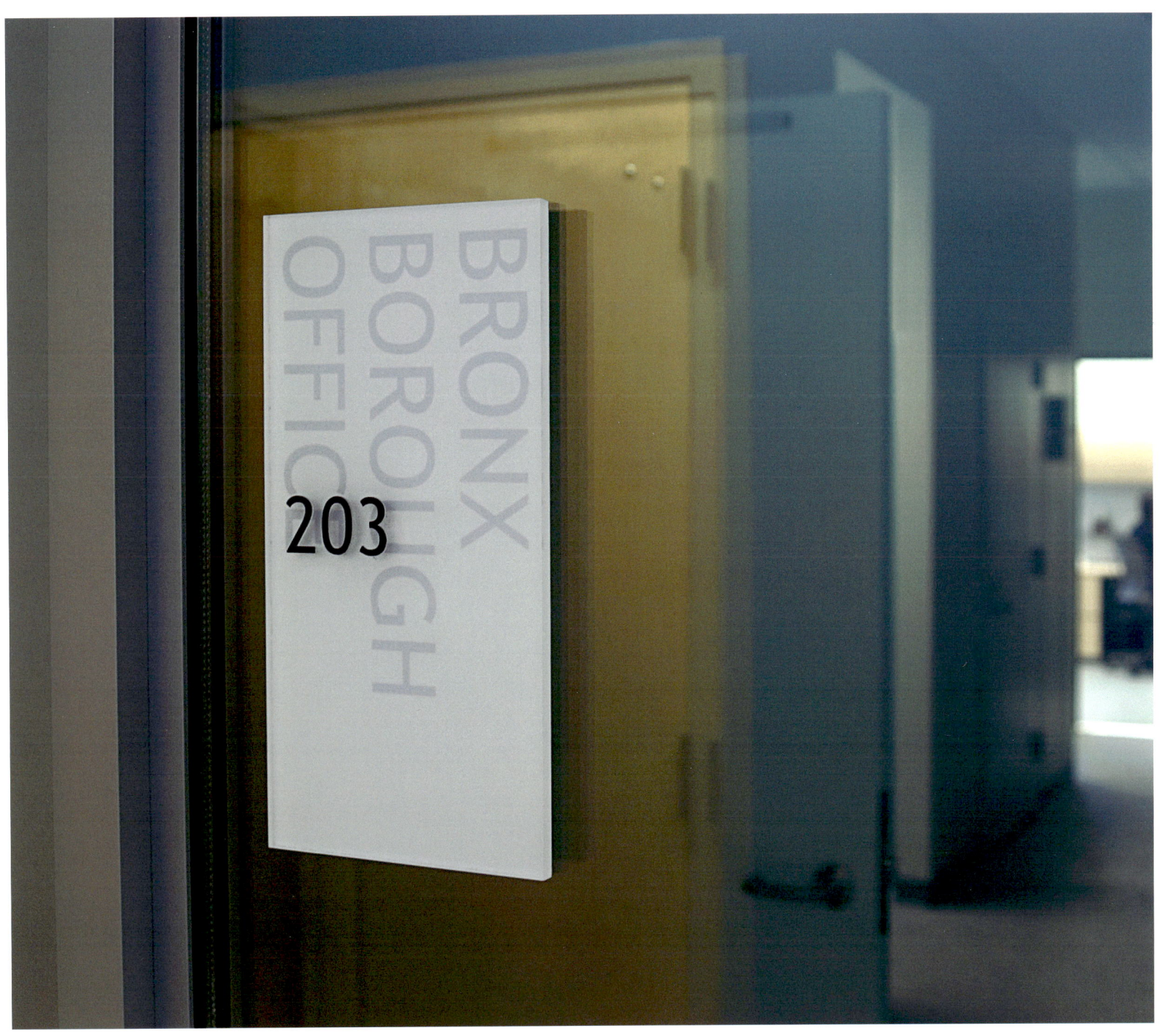

Messages are layered on glass panels suggesting the depth of meaning that comes with literacy. The layouts are active and asymmetrical. Layers of type and message reinforced the project theme of reading and meaning wherever possible. To maintain typographic standards, library staff were given pre-laid-out models for paper inserts on the stack identifiers.

>>>

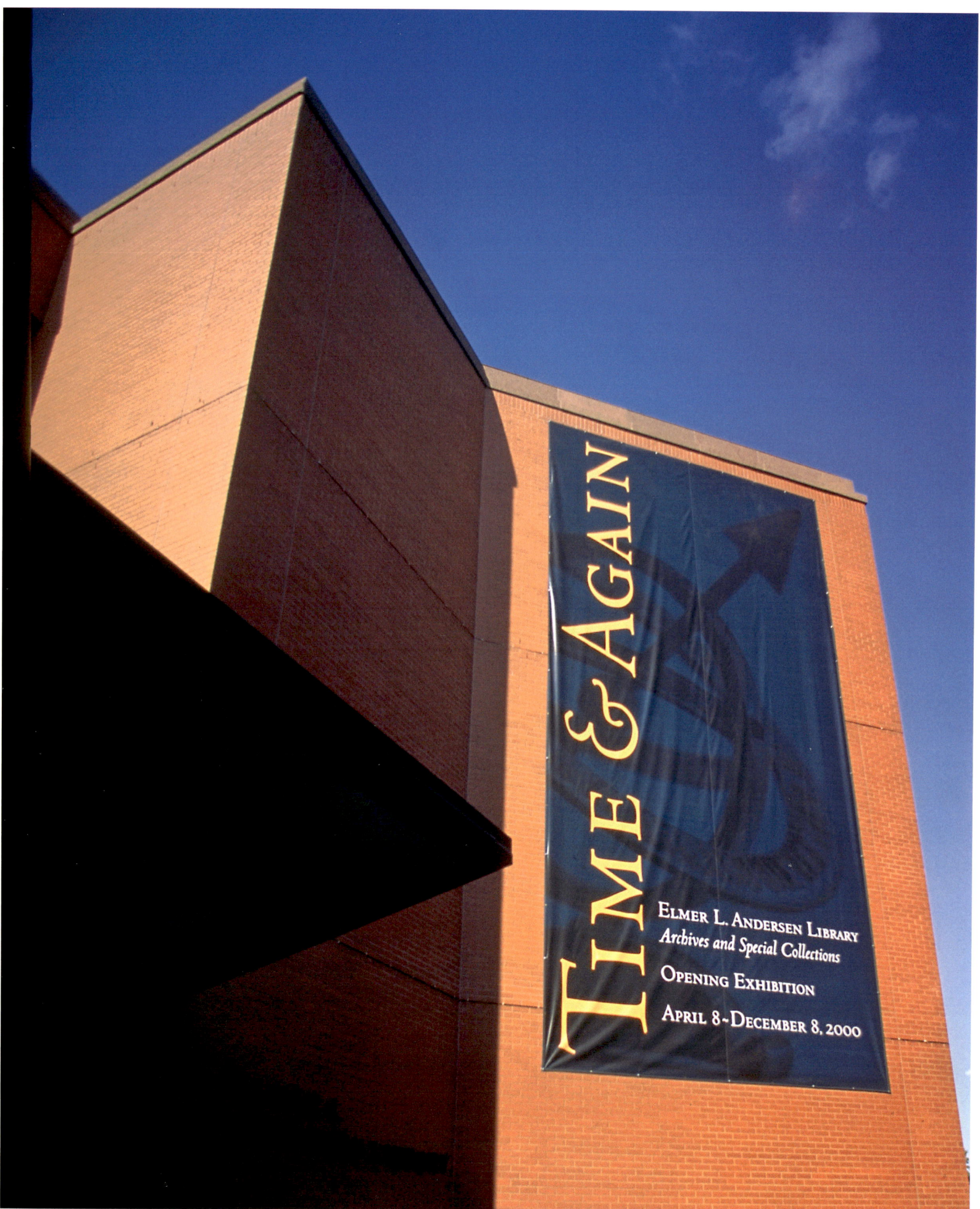

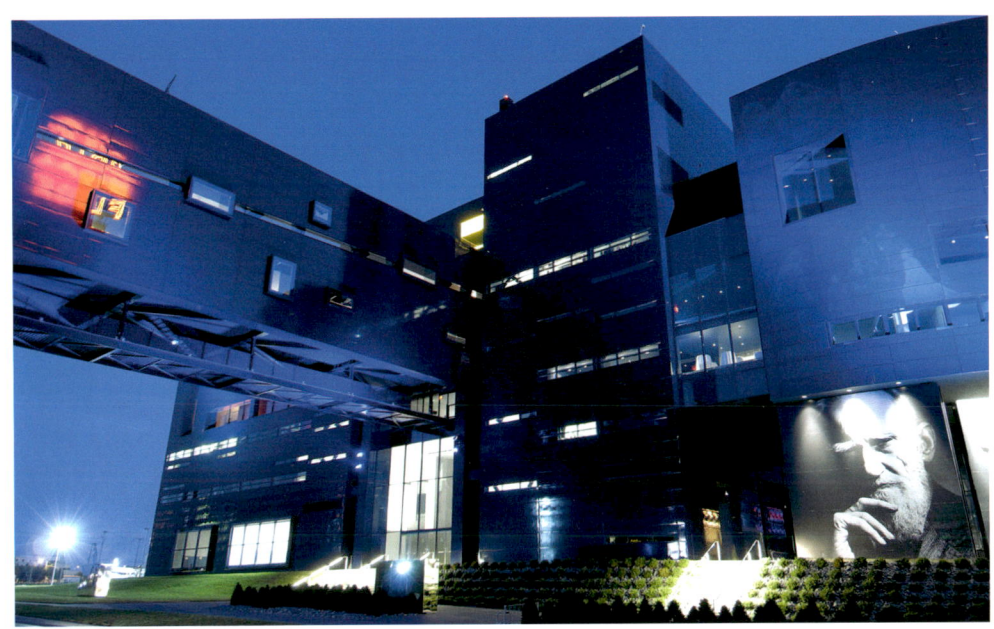

GUTHRIE THEATER

A massive steel skeleton based on blueprints by the legendary French architect Jean Nouvel went on to become a nine-story aluminum monolith featuring an "endless bridge" extending toward the banks of the Mississippi River. With three separate stages, two full-service restaurants, and an educational wing, the Guthrie presented a uniquely complicated wayfinding challenge. To address these issues, the studio decided to use a mix of traditional and new technologies, resulting in harmonious and well-balanced wayfinding that makes extensive use of interactive elements.

Location: Minneapolis, Minn., United States
Design team: Mike Haug/Larsen
Website: www.larsen.com
Main materials: brushed aluminum

>>>

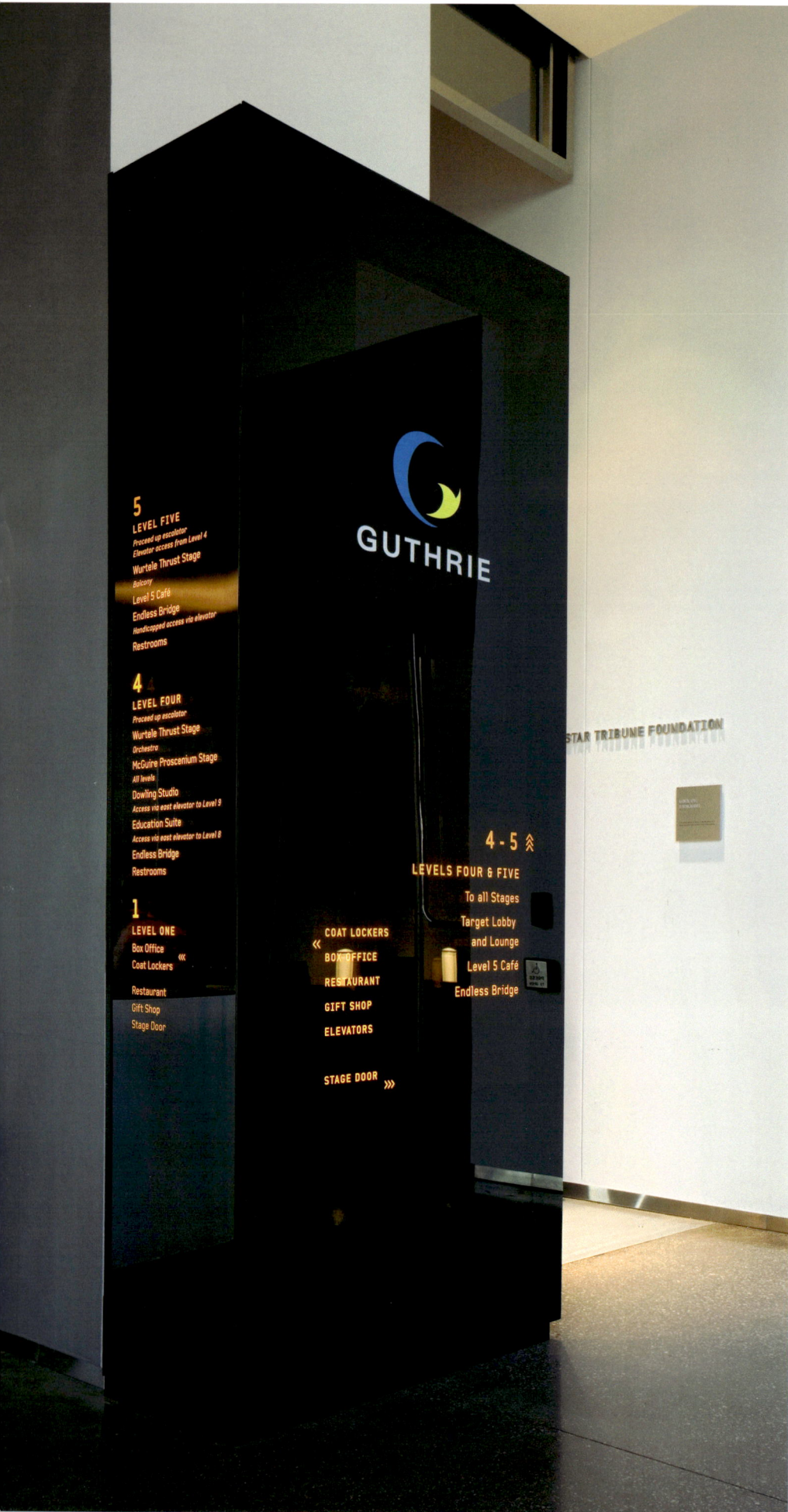

(Front page) External banners are used to advertise shows. Interactive panels inform on activities and events but also pay homage to benefactors. Adding graphics on the glass in black helps both to direct patrons and to subtly call attention to the transparent sheets. At the entrance of the building, two LCD display kiosks were placed. Featuring messages that change in order to meet the needs of the audience; the display might indicate lunch hours for the restaurants at midday or flash showtimes as evening comes on.

<<<

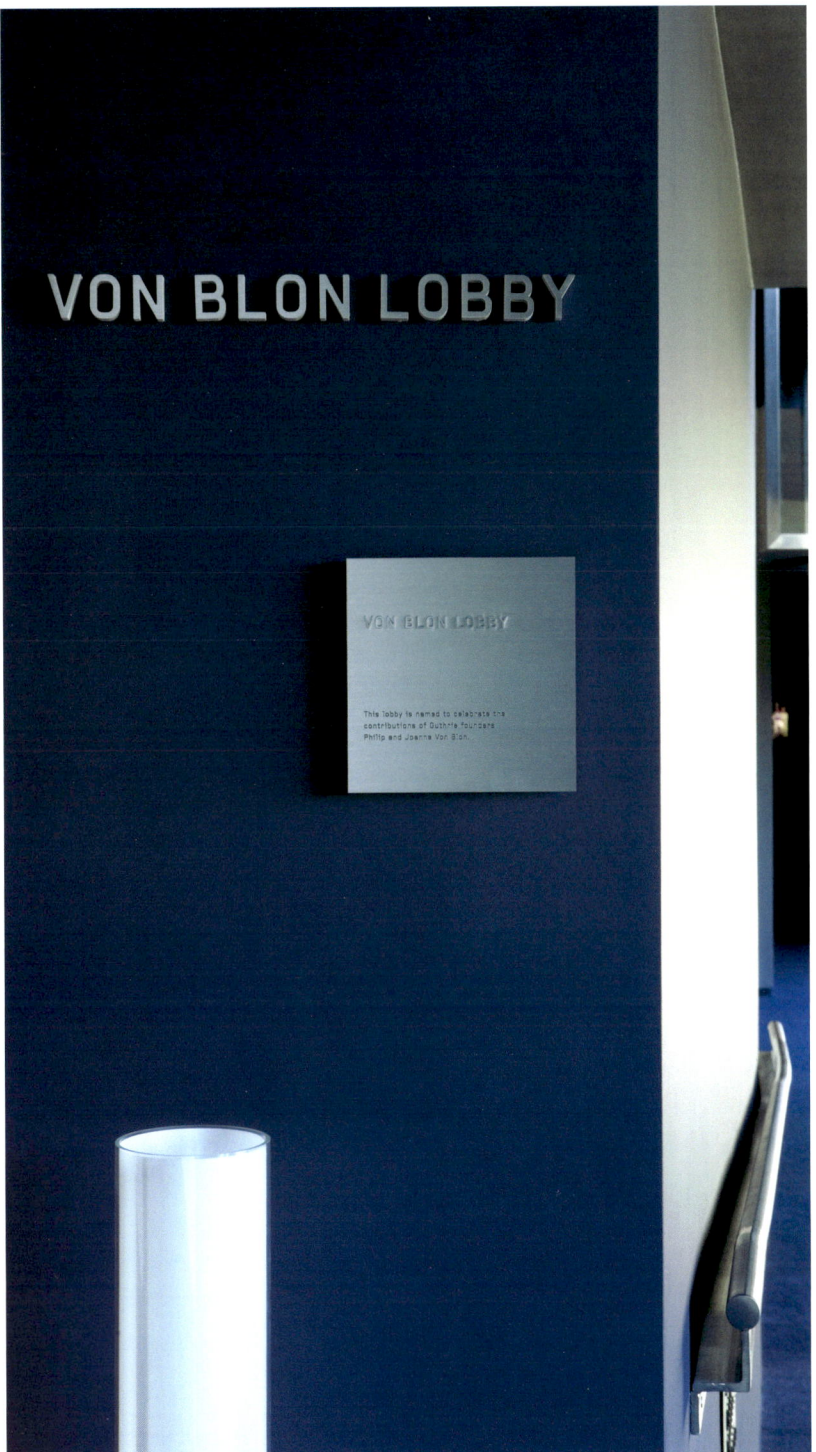

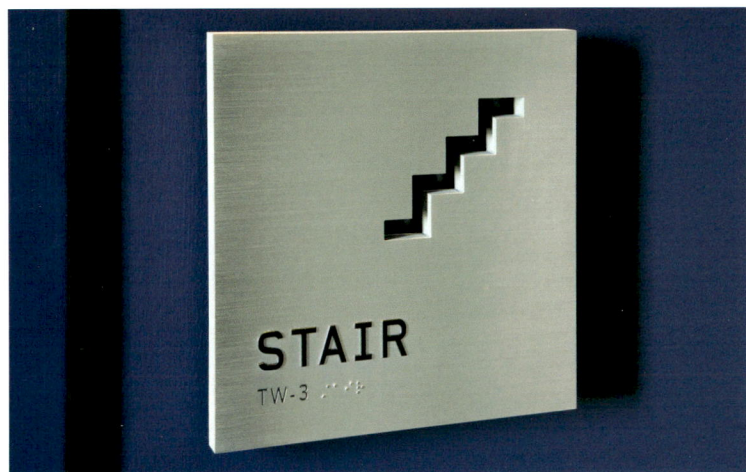

More than 1,100 signs were manufactured out of sleek brushed aluminum and backlit smoked-acrylic that recedes when the lights are dimmed. Backstage signs for the actors—some of whom may be from visiting troupes and not speak English—are color-coded according to path.

>>>

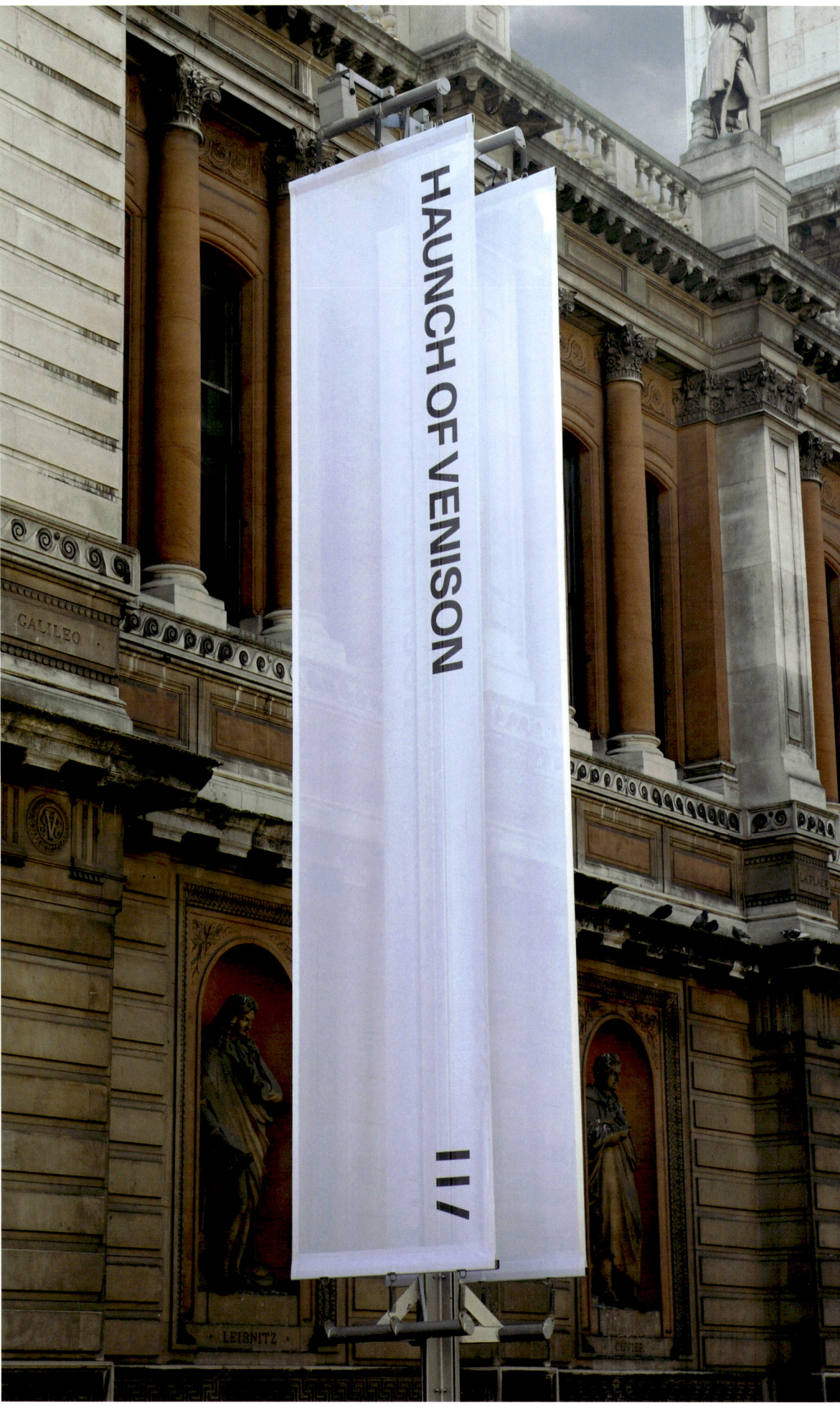

HAUNCH OF VENISON

To complement the Haunch of Venison's recent relocation to a large and prestigious new address, the sign system was completely redesigned. The new premises required an adaptable approach to signage because of the venue's multifaceted cultural offer. Simple, discreet black vinyl graphics were applied directly to the white walls to indicate the multiple spaces and exhibitions. Typographically, the choice was to use only one typeface employed throughout the gallery as an identifier. As a means of differentiating with temporary exhibitions, custom typography is also incorporated when needed.

Location: London, United Kingdom
Design team: Spin
Website: www.spin.co.uk
Main materials: paint

>>>

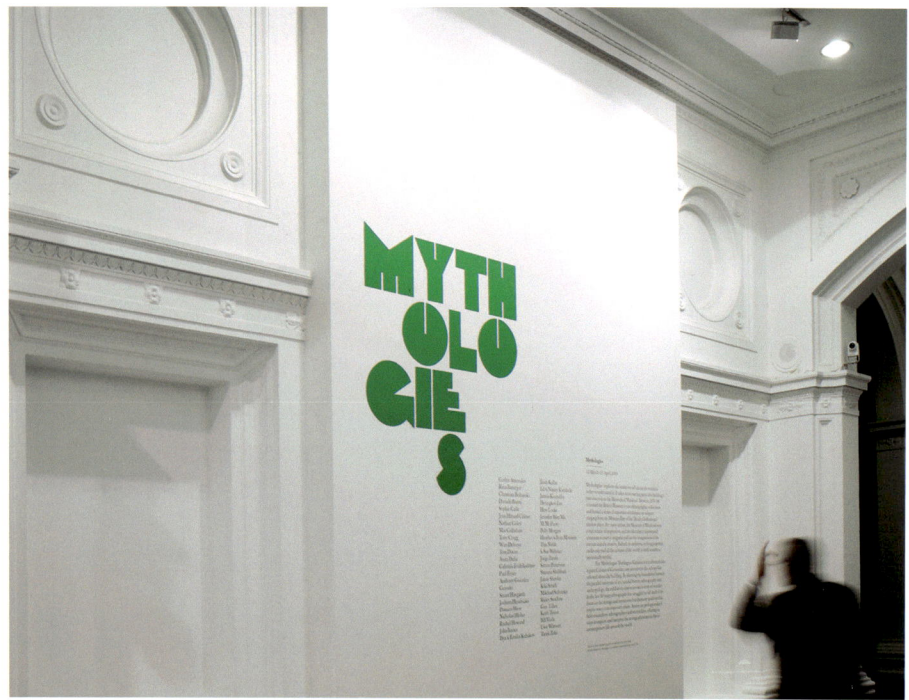

The Haas Unica family has three distinct weights, which are all used to create a signage hierarchy and help visitor wayfinding. The black on white color scheme of the signage was chosen because it allows introducing different exhibition identities. Different colors, or different font faces, integrate with ease without provoking too much visual contrast.

<<<

To allow the gallery maximum flexibility, and to reduce the costs of producing and installing endless vinyl, a reusable standing sign was designed. Staff can print out signs with a standard template and move them around the gallery as required. Simply constructed from white-lacquered MDF, the sign is shoulder-height and as wide as an A4 piece of paper—dimensions that echo the exterior on-street banners and vertical arrangement of the corporate identity.

>>>

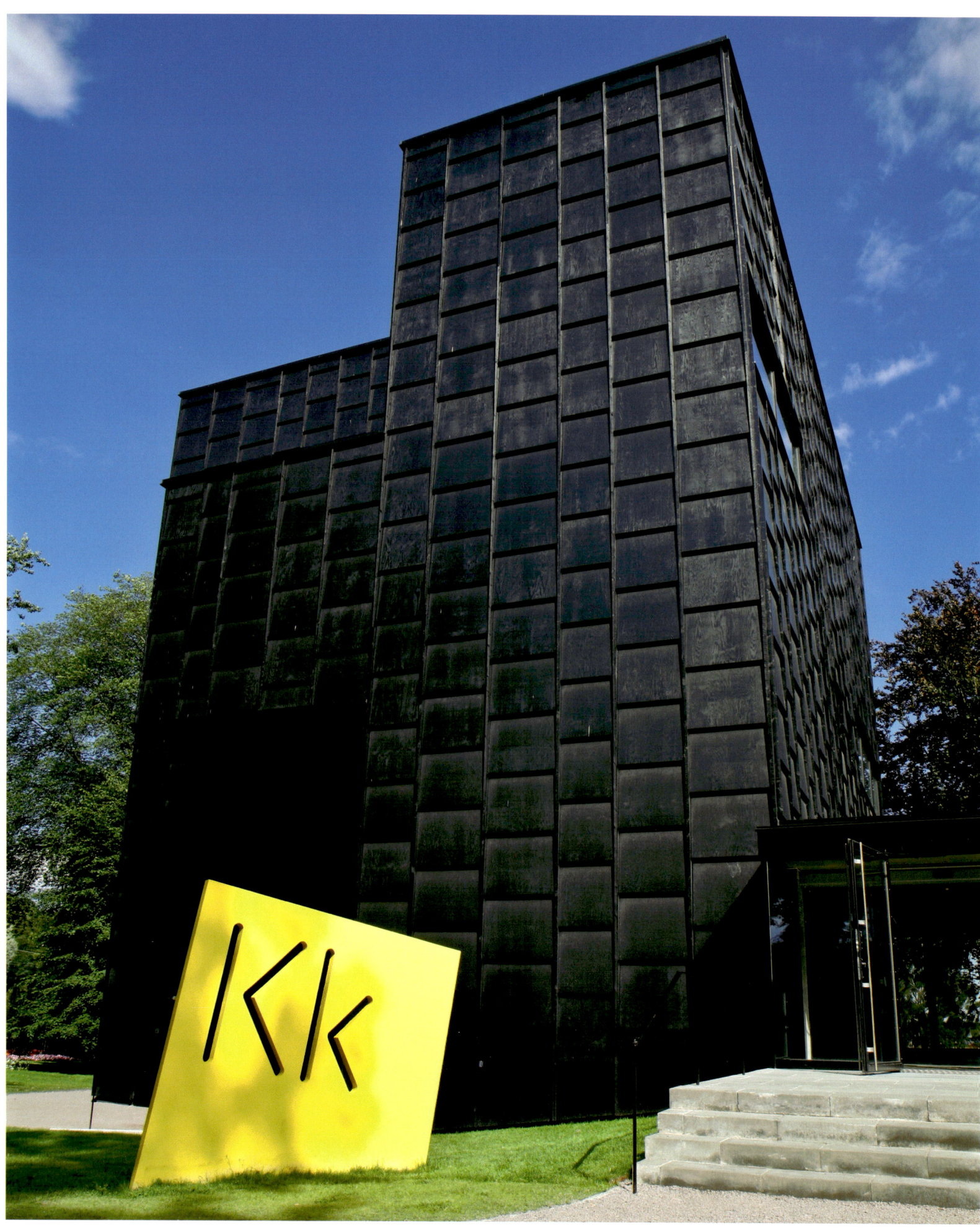

KALMAR KONSTMUSEUM

The identity and signage for Kalmar museum of art, a new space for contemporary art in southern Sweden, makes extensive use of the concrete walls to convey wayfinding information. Gaining the permission to paint on the structures was crucial, as the yellow rebounds the aesthetic while working along with the material. It could be defined as a Post-it system for buildings. The base for the sign is a square, which is also the base for the logo and letterhead graphics. The signs are painted directly over any surface needed, thus accentuating the idea that the squares are "slapped on."

Location: Kalmar, Sweden
Design team: Sweden Graphics
Website: www.swedengraphics.com
Main materials: paint, concrete

>>>

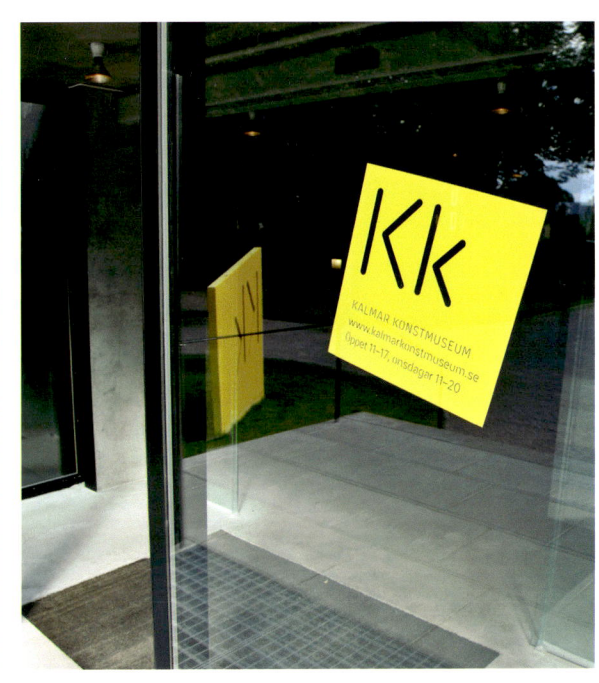

30 KALMAR KONSTMUSEUM

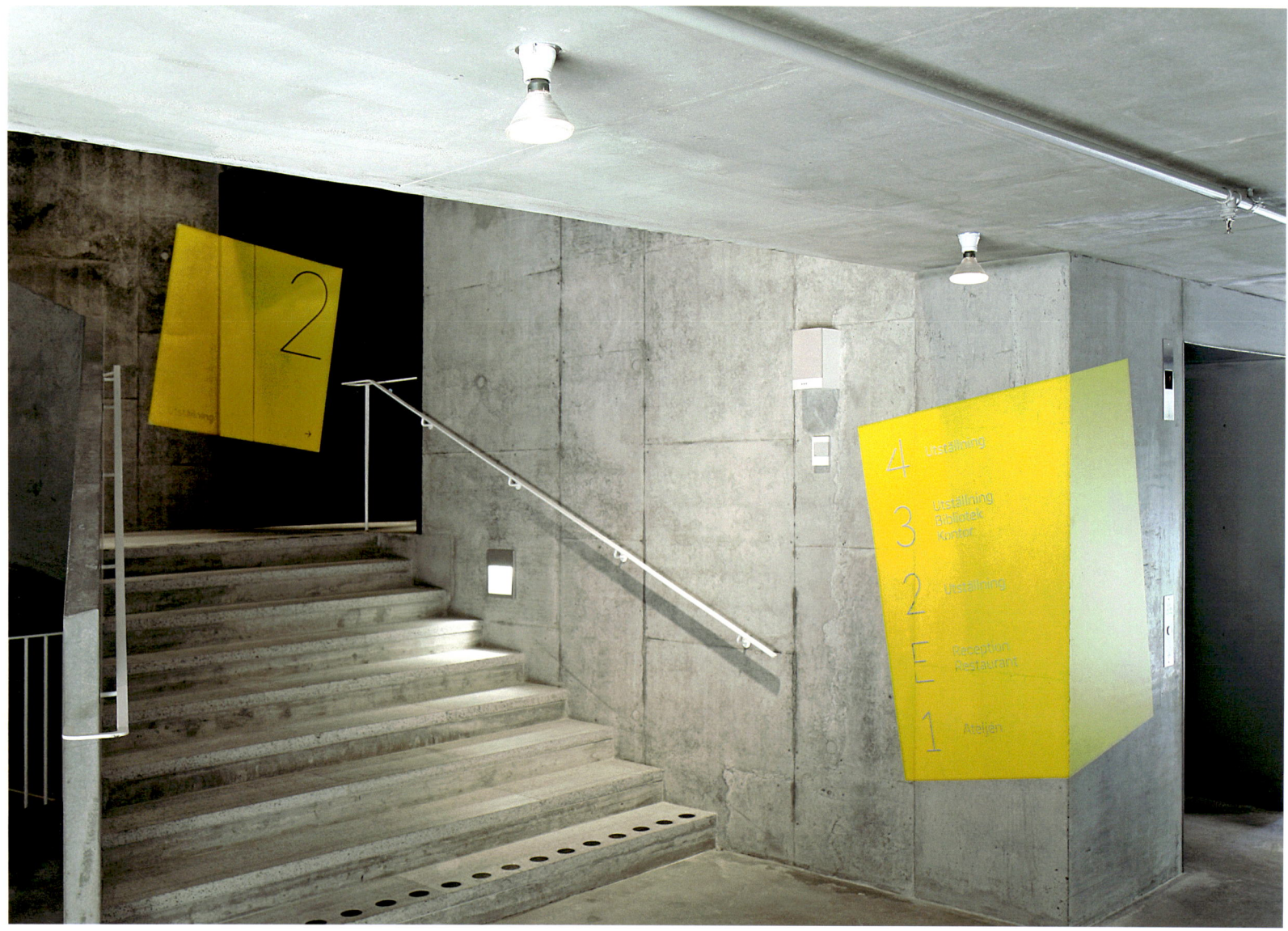

A slate logo in solid concrete is "stuck" into the ground outside the museum. Aesthetically, this works very well, contrasting against the solid black building. Visitors stop at the logo slate before entering or leaving the building and many take pictures.

KALMAR KONSTMUSEUM 31

The approach decided to design a new typeface called Kalmar Sans, which is available to the museum in a stencil and a nonstencil version. Stencil is used for big type and the other for print applications. The point sizes for both fonts and arrow signage have been kept small: visitors' attention is already caught by form, color, and shape of the sign. The stark contrast of yellow on black and gray makes the building more inviting and the architectural image more accessible.

>>>

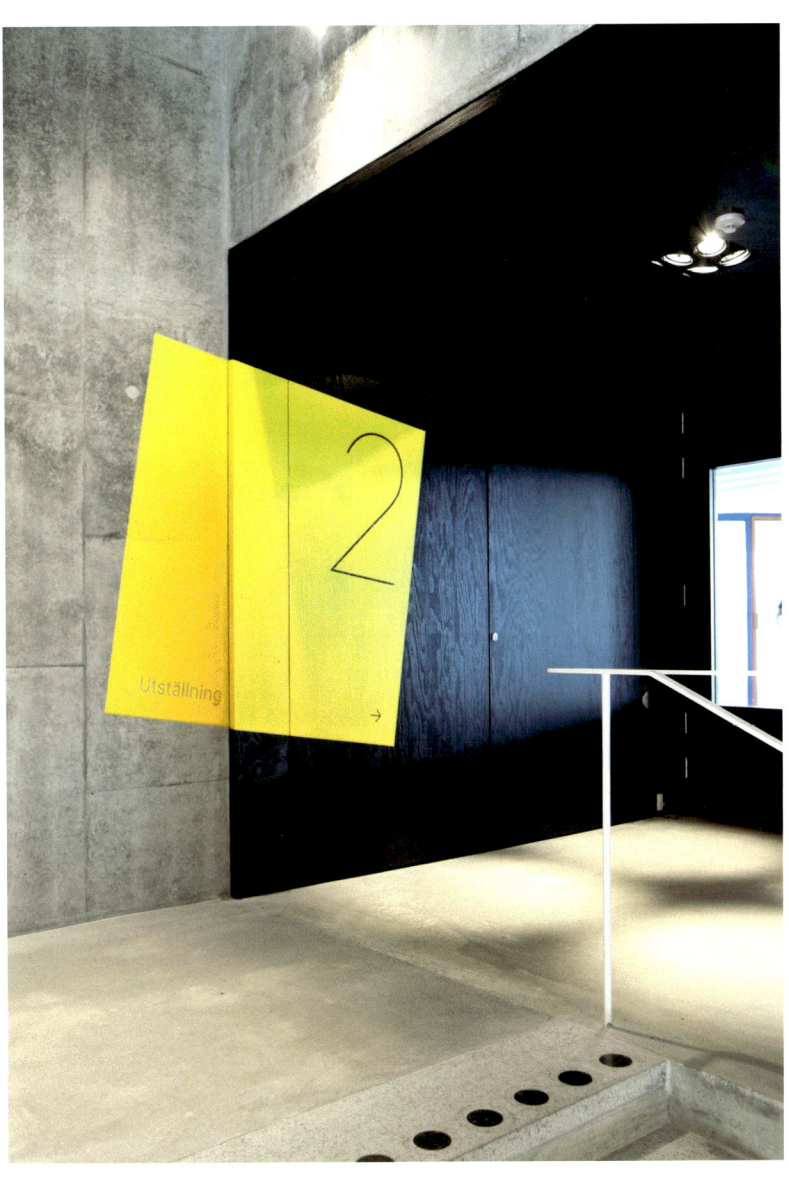

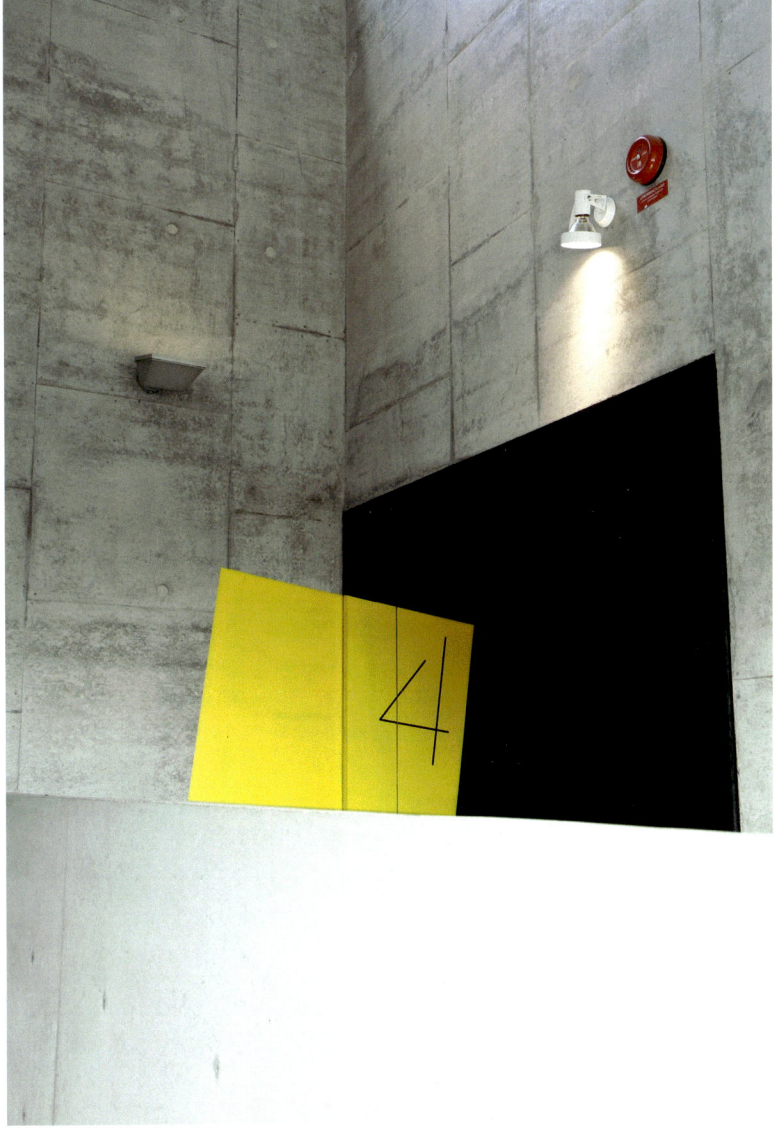

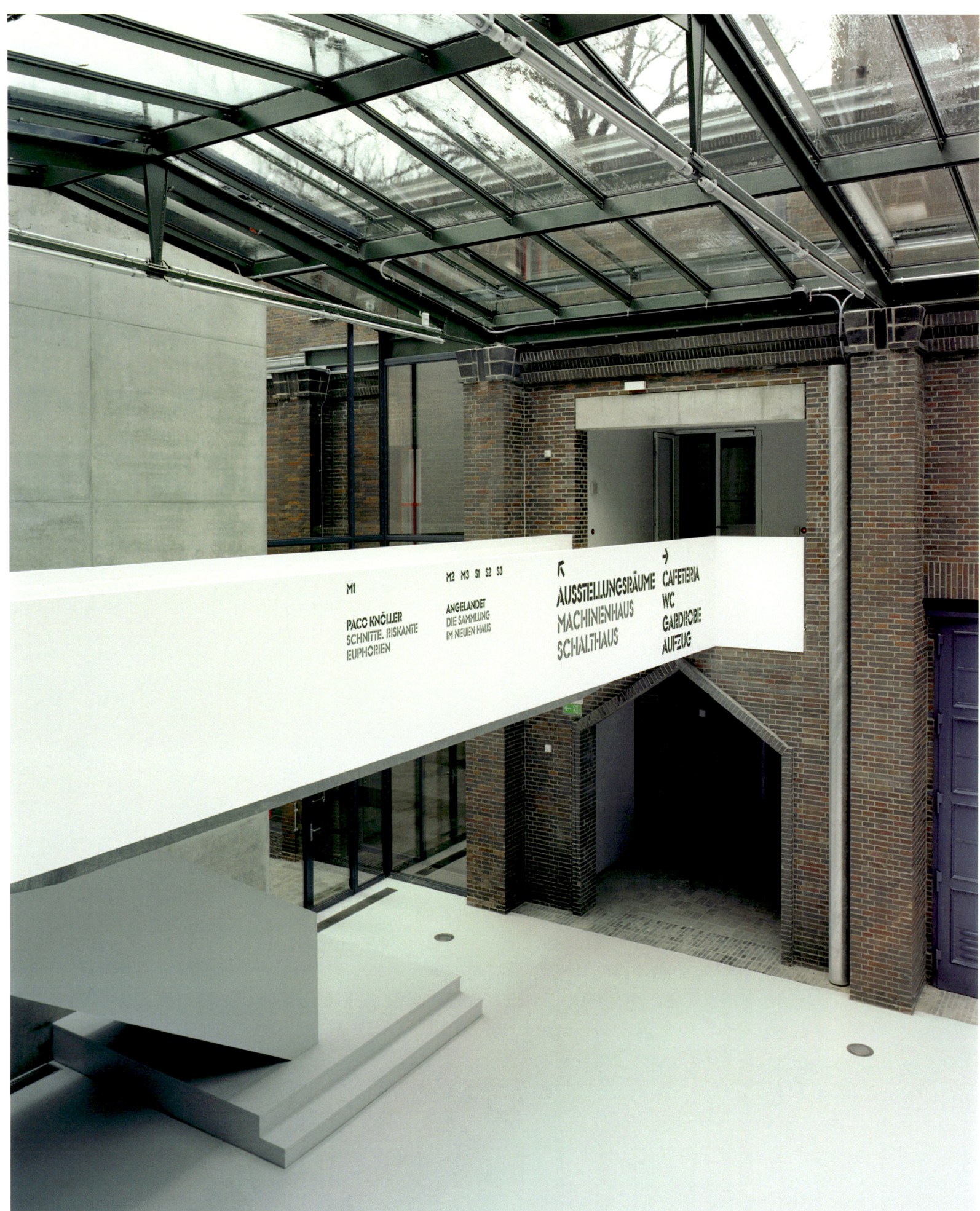

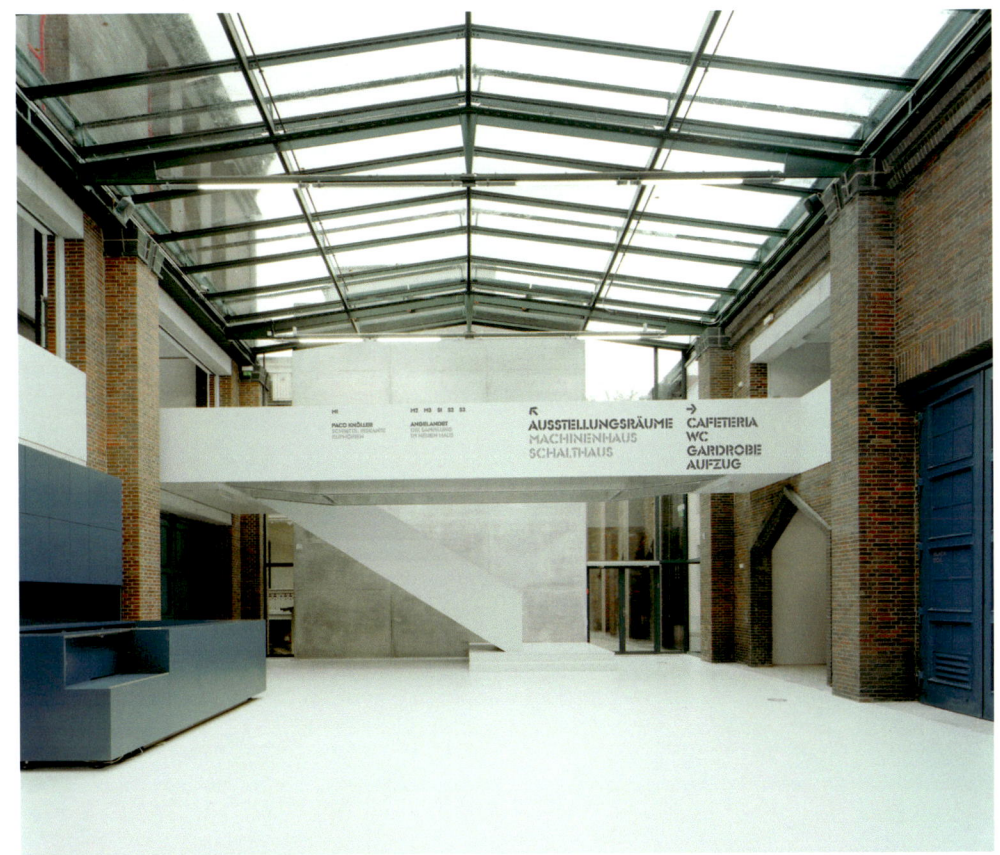

KUNSTMUSEUM DIESELKRAFTWERK

The Brandenburg Culture Foundation relocated its art museum to a defunct 1920s power station. The conversion was made by Anderhalten Architekten to provide a minimal structure for the exhibition purposes. The signage system followed this principle, keeping color scheme, typeface, and general sign placement to a minimal. The signs were painted directly on museum structures. A prominent feature is the contrast between internal and external signage: while maintaining a sober profile on the inside, the outside banners indicate the museum clearly with an attractive red hue and block type.

Location: Cottbus, Germany
Design team: Ständige Vertretung
Website: www.staendige-vertretung.com
Main material(s): paint

>>>

KUNSTMUSEUM DIESELKRAFTWERK

In such a minimalist signage system, font choice was of crucial importance. The font Neo Futura by Milton Glaser was preferred so as to establish a contrast between existing corporate font FF Meta. Moreover, the building with its brickwork required a typeface that would reflect its industrial but also modern appearance from the 1920s. Neo Futura font merges with building structure while retaining visibility. It also reflects the museum's dedication to contemporary art.

<<<

KUNSTMUSEUM DIESELKRAFTWERK 35

Visitors are immediately informed about the content of the exhibitions and shown to the respective spaces by the signage on the bridge within the foyer; nevertheless, interior wayfinding elements were also added to aid the flow through the exhibits. Royal blue was used to demarcate exhibition entrances. This choice was due to the particular nature of the doors—unmistakable and preserved from the previous structure—and to add less general clutter to the sign scheme. In the pictures one can see that the font is highly readable in both large and small point sizes.

>>>

MANCHESTER ART GALLERY

MANCHESTER ART GALLERY

After considerable refurbishment and enhancement work, new extensions to the Manchester Art Gallery created considerable orientation problems for visitors. A wayfinding scheme fixed the problem by changing the flow of visitors through the gallery while effectively linking the old building with the new extension. The identity design, which features bold typography and tonal colors, sets the style for signs in the original space and the extension. Visitor maps give a simple and effective understanding of how the building is organized and link directly to the wayfinding sign scheme.

Location: Manchester, United Kingdom
Design team: Holmes Wood
Website: www.holmes-wood.com
Main materials: stove-enameled aluminum panels with screen-printed graphics

>>>

On the Chinatown side, the building's architecture gave no indication that it was a gallery. Holmes Wood introduced a digitally printed sign fixed internally to the glass and directly targeting the Chinese audience. Visitors are aided internally by clear color-coded wall signs and custom designed pictograms. The signs were made of stove-enameled aluminum trays and the graphics were screen-printed.

<<<

MANCHESTER ART GALLERY 39

The floor plan on one side welcomes visitors and explains what is currently featured in the gallery. On the other side, it directs visitors if they want to skip the art and simply go to the shop or the café. The sign's front cover is a direct repeat of the content on some of the external banners. The monochrome floor plan uses line weight to differentiate space. Color is kept at a minimum.

40 MINNEAPOLIS CENTRAL LIBRARY

Political Science

JC421 - JC31 JK34 - JK524

Political Theory United States
General Works
Comparative Works
United States

ⓘ

∧ History/Social Sciences

> Athenaeum
 Special Collections
 Restrooms

< Foundation Center
 New Americans Center
 Copiers and Printers

MINNEAPOLIS CENTRAL LIBRARY

This new building brings the library concept into the twenty-first century. The structure offers a unique challenge for wayfinding. The building is five stories high and occupies an entire city block. The open architecture and high ceilings of each floor make it difficult to place signage. The wayfinding experience had to take into account the fact that visitors have very different uses for the library and often, multiple destinations. The studio had the chance to work with the architectural team to create a wayfinding strategy. The result was a strong typographical identity that varies from metal to LCD systems.

Location: Minneapolis, Minn., United States
Design team: Mike Haug/Larsen
Website: www.larsen.com
Main materials: LED, Plexiglas

>>>

42 MINNEAPOLIS CENTRAL LIBRARY

Larsen designed a series of translucent glass signs set off with aluminum hardware and supports. The primary directional signs use LED-embedded glass panels that illuminate the information symbol, used as a focal point for lost visitors. The system includes flat-screen computer monitors with active text to help visitors find their way to events throughout the building. Children and teen sections were enhanced with 3-D symbols that point the way to the entrances. When there was less need for flair, opaque Plexiglas mounted on aluminum bars was used.

MINNEAPOLIS CENTRAL LIBRARY 43

The architecture of the building, with high clearances and tall ceilings, offered few places for applying metal signs. A graphical solution was to simply tilt the signs in vertical. This alignment went on to become a popular theme in the entire building signage. The consultation booths represent a quick way to find library sections and reading rooms. These were specifically designed with four different screens at an inclined angle to be read by multiple users at the same time and by people of different heights.

MUSÉE DE LA PHOTOGRAPHIE 45

MUSÉE DE LA PHOTOGRAPHIE

Following cues from photography concepts such as transparency and color division, the designers implemented a highly functional signage for this photography museum based entirely on Plexiglas. This material was chosen because of its vast chromatic range, versatility, transparency and opacity. Plexiglas is customizable and easy to install. The rectangles are reusable, easily rearranged, and easily stored. The use of a rounded sans serif typeface on the sign adds to its "snapshot" appearance.

Location: Brussels, Belgium
Design team: Designlab
Website: www.designlab.be
Main materials: Plexiglas

>>>

46 MUSÉE DE LA PHOTOGRAPHIE

Notable characteristics of this signage are the typeface and the position of the signs. The close-up image of the typeface shows how no uppercase letters were used. This is to render the rounded typeface letters uniform and easily readable. The position of the sign is also a fundamental part of its appearance. The Plexiglas rectangles are leaned on the walls, fixing only the top part.

MUSÉE DE LA PHOTOGRAPHIE 47

Visitor circulation throughout the museum was researched thoroughly before the implementation of its signage system. Color is used both to generate aesthetic contrasts and as an information code. The use of different opacities on the signs creates the designers' sought-after light/shadow effect.

>>>

48 POWERHOUSE MUSEUM

POWERHOUSE MUSEUM 49

Welcome. Please come in.
*Gumul cowarna nula**

The Powerhouse Museum is Sydney's great museum of design and technology, celebrating human creativity and innovation in ways that engage, inform and inspire.

Enjoy your visit.

The Museum operates on three sites:
Powerhouse Museum, Ultimo
Powerhouse Discovery Centre, Castle Hill
Sydney Observatory, The Rocks

*Eora, the language of the first people of the Sydney region.

ph^m

Directory

5 Level 5
Boardroom

4 Level 4
Members Lounge
Exhibitions
Cinema India

3 Level 3
This Level
Cafe
Shop
Entry/Exit foyer
Exhibitions
Inspired!
Strasburg Clock model
Boulton and Watt engine
Locomotive No 1
Success and innovation
Smart works

2 Level 2
Toilets
Parents room
Theatres
Powerhouse Learning Centre
Exhibitions
'...never done'
What's in store?
Kings Cinema
Australian Communities Gallery
The steam revolution
● Zoe's House
● SoundHouse
● VectorLab
Lace Study Centre
Fashion from fleece

1 Level 1
Toilets
Courtyard Cafe
Cogs' Playground
Turbine Hall
Exhibitions
Cyberworlds
Musical instruments
Experimentations
Space
Transport
EcoLogic
Special FX

POWERHOUSE MUSEUM

A refurbished power station, this museum is arranged in a complicated assembly of spaces and displays, making it difficult for visitors to find their way around. Adding to the complexity is the fact that people don't enter at ground level, and therefore find it difficult to understand the numbering of the floors. The architecture and exhibitions are highly layered and often visually overwhelming, and in many locations the signage system needs to work with distinctive exhibition graphics and low light levels. The use of color-coding and extensive arrow signage was the preferred solution.

Location: Sydney, Australia
Design team: Frost
Website: www.frostdesign.com.au
Main materials: vinyl, paint, cardboard

POWERHOUSE MUSEUM

The creative clue came from the building's history—with bold color and a chevron graphic referencing industrial signage. Monumental numbers were applied to the inside of the lift well and at the top and bottom of the escalators to reinforce each level. The solution also meant the system could have the necessary impact, and was displayed on a system of clear and distinct white monolith blocks that were located at key decision points around the museum.

POWERHOUSE MUSEUM 51

The numbers are also emblazoned on all level signs and combined with color-coding. The type arrangement draws on rational Swiss-modernist typographic arrangements and pictograms and large arrows to make it universal for international and local visitors.

>>>

52 CINEMA SAUVENIÈRE

CINEMA SAUVENIÈRE

This signage scheme takes hint from the building's function as a cinema. Using transparent elements, the studio focused its work on "opening" toward the outside a building type that is by definition folded on itself. The graphical solution consisted in incorporating concepts of transparency, light, colors, and image superposition. This was achieved by making light boxes as signs and using very practical lighting in the dark environments of the movie theater. Color was kept to black and white to create a bond between the old city and a very contemporary building.

Location: Brussels, Belgium
Design team: Designlab
Website: www.designlab.be
Main materials: backlit Plexiglas

>>>

54 CINEMA SAUVENIÈRE

In times of great visitor flux—such as during a movie premiere—the crowd might block the wall signs. This was solved by painting directions on the vertical rises of staircases. The black and white scheme is in agreement with the color of the architecture. The simple appearance of the typeface hides its rich hierarchy. The font has four different weights and they are used according to the importance of the information conveyed.

CINEMA SAUVENIÈRE 55

The signage was implemented after a few months of research. The findings highlighted a need to refine the program of circulation toward the movie halls. Although standard, the pictograms were adapted to the general elegant appearance of the signage by slight readaptations. Luminous boxes are a perfect solution for this cinema: they bind the building's lines and reliefs while irradiating a white gleam, re-creating the effect of a screen in a dark room.

SCIENCE GALLERY 57

SCIENCE GALLERY

Science Gallery is a public creative space and gallery. The venue hosts permanent offices and an interchanging variety of exhibitions that redefine the usage and physical space. The elements are in fact very heterogeneous: various types of vinyl from tiny captions to 485-sqare-foot external banner signage, laser-cut Perspex (PMMA) and metal as well as projected graphics. Different materials are used in different contexts, keeping Trade Gothic as the only typeface. PMMA was used as an alternative to glass, and it was preferred because of its easy handling and processing, and low cost.

Location: Dublin, Ireland
Design team: Detail
Website: www.detail.ie
Main materials: Perspex

>>>

The combination of shapes and stark black/white contrast are perfect for positioning info booths and reception desks. The permanent wayfinding in the gallery spaces is manufactured from a combination of painted and edge-lit Perspex, wall-mounted with a "shadow gap" or hanging. A closer look at the "shadow gap" shows the lighting effect that the neon Perspex gives out.

<<<

SCIENCE GALLERY 59

Every temporary exhibition gets a customized signage and some of the permanent wayfinding can be rearranged according to specific needs. To accommodate these changes, the system is based on a simple yet effective combination of shapes that address the problem of accessibility to a huge space that is often modified to host temporary exhibitions. Also, each of the exhibitions needs to be promoted using standard channels—posters, fliers, catalogs, postcards, and advertising in print and online.

>>>

60 SPERTUS INSTITUTE

SPERTUS INSTITUTE

Upon relocating to a new building with a ten-story faceted glass façade in downtown Chicago, the Spertus Institute needed a new signage system. The typographic system is a "study in light." The key design element is a typographic system that combines a modern sans serif with a traditional serif italic font in order to connect the new premises with the spirit of Jewish tradition. On two sides of the interior glass surfaces, these two fonts create a "flickering" typeface—serving as the candlelight of the logo brought to life in architectural space.

Location: Chicago, Illinois, United States
Design team: Studio/lab
Website: www.studiolab.com
Main materials: vinyl, Plexiglas

>>>

Asher Library

ENDOWED BY NORMAN & HELEN ASHER

Monday – Wednesday 10 am – 6 pm
Thursday 10 am – 7 pm
Friday 10 am – 3 pm
Closed Saturday
Sunday 10 am – 4 pm

Open online
24 hours a day, 7 days a week
at www.spertus.edu

The façade of the Spertus building was inspired by the Spertus tagline: "let there be light." Studio/lab further developed a custom type treatment to embrace underlying concept and extend it to all decorative typographic signage. Flicker type became the primary graphics theme within the building. Overlapping, translucent type (a modern sans serif paired with a traditional italic serif) on both sides of glass reinforces the concept of the encounter of modern and traditional.

SPERTUS INSTITUTE 63

Spertus employees collected quotes written by Jewish poets, comedians, actors, and scholars to represent the different programmatic areas of the building. As a contrast, elegant, architectural-scale directories placed between the main elevators on each floor allow clear and simple wayfinding for visitors. Each directory indicates the active floor through its large "flicker number" and specific floor information is etched with a dark color. Information for inactive floors is also revealed, though lightly etched.

TATE MODERN

A cultural entity as important and quick-changing as the Tate needed a signage system of maximum elasticity and sophistication to meet the requirements of its kaleidoscopic offer and visitors needs. The building is arranged over seven floors served by three entrances and a mixture of elevators and stairs. It houses permanent collection galleries, changing exhibition spaces, an education center, café, espresso bar, and restaurant. The solution envisioned comprises an elegant image while retaining flexibility with multifunctional vinyl totem posts.

Location: London, United Kingdom
Design team: Holmes Wood
Website: www.holmes-wood.com
Main materials: vinyl, paint

>>>

66 TATE MODERN

On the front page: it's clear how large reverse-cut frosted vinyl graphics were introduced on all glass walls, reducing the need for cumbersome signposts. Analyzing the vinyl graphics, it's clear how the scale is part of the image of the gallery. Level numbering, vinyl graphics: along with the architects it was decided to use architectural substrates rather than introduce sign furniture. The brief called "book jacket" entrances; thus vinyl graphics were applied direct to the architecture.

<<<

Pantone 405 brown was used throughout the building, with white used only on dark surfaces. A four-sided column sign worked as an updatable floor directory (the graphic is a digital print, laminated for durability and applied to the steel panel), a leaflet rack for the map, and a donation box and a surface worked for daily events posters that can be applied using magnets to the steel substrate.

>>>

TATE MODERN 67

Level	Area	Details
7	Café	East Room
6	Members Room	
5	Galleries	Information / Reading Areas / Meeting Point
	Nude – Action – Body	
	History – Memory – Society	
4	Exhibitions	Espresso / Shop / Tickets / Meeting Point
	Between Cinema and a Hard Place	
3	Galleries	Studio C / Tate Audio / Reading Areas / Meeting Point
	Still Life – Object – Real Life	
	Landscape – Matter – Environment	
2	Platform	North Entrance / West Entrance / Café / Shop / Starr Auditorium / Film and Seminar Room
	The Unilever Series: Louise Bourgeois	
	Herzog & de Meuron	
1	Turbine Hall	West Entrance / Information/Tate Audio / Tickets/Members / Shop / Clore Education Centre / Clore Study Room / McAulay Studios
	The Unilever Series: Louise Bourgeois	

What's on today

Event	Time
Guided Tour – Meeting Point Level 3 — Highlights of History/Memory Society	10.30
Guided Tour – Meeting Point Level 5 — Highlights of Nude/Body/Action	11.30
In Focus – Film and Seminar Room, Level 2 — Picasso's Weeping Woman With Richard Thomas	12.30
Guided Tour – Meeting Point Level 3 — Highlights of Landscape/Matter/Environment	14.30
Guided Tour – Meeting Point Level 5 — Highlights of Still Life/Object/Real Life	15.30

Events are free unless stated £
Tickets for paid events can be purchased
from the Box Office in the Turbine Hall, Level 1

68　TATE MODERN

The building's main logo graphics was designed by renowned studio Wolff Olins. By rounding and softening edges on the custom pictograms, Holmes Wood was able to integrate both elements. The pictograms are designed to be reproduced at the tiniest point sizes by increasing the proportion between small and large elements (that is, heads are drawn slightly bigger).

<<<

TATE MODERN 69

MODERN TATE

Map
May 2004

3/05

7 Restaurant
 Bar

6 Members Room

5 Collection 2004

4 Exhibitions
 Espresso Bar
 Shop

3 Collection 2004
 Studio C

2 Café, Untitled Gallery
 Starr Auditorium
 Seminar Room

1 Shop, Cloakroom,
 Clore Education Centre,
 McAulay Studios
 Turbine Hall

 Head to Head
 Until 30 August

 a Clore Information Room
 b Clore Education Centre
 c McAulay Studios
 • Free Guided Tours
 ■ Architecture Audio Tour
 ■ Tickets/Information/
 Members/ Tate Audio

Collection 2004 5

History/Memory/Society | **Nude/Action/Body**

Rita Donagh	Andy Warhol	Society Through the Lens	Gerhard Richter	The Projected Image	Emma Kay		Chimney		Matthew Barney: Cremaster 5	The Fetishised Body	Eccentric Abstraction	Alberto Giacometti & Jean Dubuffet	
An Art of Commitment		Trace of Time			Monuments II		In Focus: Neo Classic		Chris Ofili	Olafur Eliasson: Your Double Lighthouse Projection		Henri Matisse & Auguste Rodin	
A History of Modern Art at Tate	Shattered Visions	Utopia	Revolution	Monuments I					Naked & Nude	Alice Neel	The Myth of the Primitive	After Us, Liberty	Georg Baselitz: Gothic Maidens

Free Guided Tours 11.00 and 12.00

Exhibitions & Displays 4

Constantin Brancusi
29 January – 23 May
Sponsored by Aviva plc
Constantin Brancusi (1876–1957) was one of the founding figures of modern sculpture and one of the most original artists of the twentieth century. This exhibition brings together around forty of his sculptures and is the first major exhibition in the UK dedicated to his works.
Admission £8, £6 concessions, tickets on sale on Level 4.

Constantin Brancusi Sleeping Muse I
1909–10 Hirshhorn Museum and Sculpture Garden, Smithsonian Institution © ADAGP, Paris and DACS, London 2004

Edward Hopper Cape Cod Morning 1950
© The Smithsonian American Art Museum; Gift of the Sara Roby Foundation

Coming soon
Edward Hopper
27 May – 5 September
Sponsored by American Airlines
Foundation Supporter: The Henry Luce Foundation
Edward Hopper (1882–1967) is considered the pre-eminent painter of modern America and many of his works have become iconic images of the twentieth century. This major retrospective is the first in the UK for over twenty years and includes over eighty works. Advance tickets on Level 4 and at www.tate.org.uk/tickets or call 020 7887 8888 (booking fee applies).

Maps also show the detail of what is on display in the rotation Tate collection. The fold creases were designed to avoid interfering with the information graphics, which are color-coded to match the entrance colors. The floor plans are shown within the map. Looking through the Turbine Hall, the isometric cutaway explains the overall offer throughout the seven floors.

>>>

ZECHE ZOLLVEREIN

This abandoned coal mine in Essen, Germany, was listed as a UNESCO World Heritage Site in 2001. Its dimensions are those of a city district. The challenge of its signage was to answer the needs of a half million visitors a year while coping with monument conservation regulations. The design intention was to create a wayfinding system with the least amount of conventional signs. The most prominent solution was haptic wayfinding. At all entrances visitors find miniature cast-iron 3-D models of the complete area, and use them to navigate the coal mine.

Location: Essen, Germany
Design team: F1RSTDESIGN
Website: www.f1rstdesign.com
Main materials: cast iron, milling, LEDs, anodizing print

>>>

72 ZECHE ZOLLVEREIN

C KOKEREI

- 70 Infopunkt Kokerei
 Kokerei Café & Restaurant
 Denkmalpfad Kokerei
 [Mischanlage]
- 72 Sonnenrad saisonal
 Solarkraftwerk
- 74 Eisbahn saisonal
 [Druckmaschinengleis]
- 75 Werksschwimmbad saisonal
- 84 Erwin L. Hahn Institute for
 Magnetic Resonance Imaging
 [Leitstand]
- 87 Büro Zollverein Touristik
 Zeitsprung
 [Salzverladung]
- 88 The Palace of Projects
 von Ilya und Emilia Kabakov
 [Salzlager]

B SCHACHT 1/2/8

- 43 Kunstschacht Zollverein
 [Maschinenhaus]
- 44 Museumspfad Zollverein
 [Fördermaschinenhalle]
- 45 PACT Zollverein
 Choreographisches Zentrum NRW
 Tanzlandschaft Ruhr
 [Waschkaue]
- 48 RAG Bildung
 Kompetenzzentrum Zollverein
 [Hauptmagazin]
- 52 Keramische Werkstatt
 Margaretenhöhe
 [Baulager]
- 55 Blauer Elefant Zollverein
 [Alte Verwaltung/Beamtenwohnhaus]
- 57 Verwaltungsgebäude Asienhaus
 [Verwaltungsgebäude]
- 58 designstadt zollverein / in Planung
- 59 designstadt no. 1
 Büros und Ateliers

A SCHACHT XII

- 1 [Schachthalle, Fördergerüst]
- 2 Stiftung Zollverein
 Kulturbüro Zollverein
 [Schalthaus]
- 4 Halle für temporäre Ausstellungen
 [Fördermaschinenhalle Süd]
- 5 Veranstaltungshalle
 [Zentralwerkstatt]
- 6 Entwicklungsgesellschaft Zollverein
 [Elektrowerkstatt]
- 7 red dot design museum
 Design Zentrum Nordrhein Westfalen
 [Kesselhaus]
- 8 [Hochdruckkompressorenhalle]
- 9 Casino Zollverein
 [Niederdruckkompressorenhalle]
- 10 Büros und Ateliers
 [Werkstatt Nord]
- 11 [Fördermaschinenhalle Nord]
- 12 Shops und Ateliers
 Veranstaltungshalle
 [Lesebandhalle]
- 13 LA PRIMAVERA
 Maria Nordman
 [Kesselaschebunker]
- 14 Besucherzentrum
 Route d. Industriekultur
 Café Kohlenwäsche
 "aussichtsreich"
 Museumspfad Zollverein
 [Kohlenwäsche]
- 18 Museumspfad Zollverein
 [Wagenumlauf]
- 21 Interartes
 [Kühlturm II]
- 24 Wildnis vor der Haustür
 [Stellwerk]
- 35 Zollverein School
 of Management and Design

WELTERBE ZOLLVEREIN
WORLD HERITAGE ZOLLVEREIN

C KOKEREI / COKING PLANT
- Infopunkt / Info point
- Öffentliches WC / Public WC
- Behinderten-WC / Disabled WC
- Behinderten-Parkplatz / Disabled parking
- Gastronomie / Restaurants
- Café, Snack
- Kinderspielorte / Playgrounds
- RevierRad-Station / Bike station

Zugang Kokerei / Coking plant entrance
Tor 3 / Gate 3

Zufahrt Mitte / Access road central

Zugang Kokerei / Coking plant entrance

Arendahls Wiese
Bus 183

Skulpturenwald / Sculpture forest
Bus 183 »Kokerei«
»Kohlenwäsche«

Wiegeturm / Weighing tower

Schacht 4/5/11 / Shaft 4/5/11
Triple Z [4 km] →

Bahnhof / Station »Essen Katernberg Süd«

Skulptur / Sculpture
Ulrich Rückriem
„Castell"

Fritz-Schupp-Allee

Pavillon Skulptur Observatorium /
Pavilion Sculpture Observatorium

B SCHACHT 1/2/8
SHAFT 1/2/8

A SCHACHT XII / SHAFT XII

Bullmannaue

Zufahrt Süd / Access road south
Zugang Schacht XII / Shaft XII entrance
Gelsenkirchener Straße
Zufahrt Nord / Access road north

Straßenbahn 107/Bus 183 / Tram 107/bus 183
»Zollverein Süd«
Essen Hbf. ← Richtung → Gelsenkirchen/Katernberg
Essen main station ← towards → Gelsenkirchen/Katernberg

Straßenbahn 107 / Tram 107
»Zollverein«

Straßenbahn 107/Bus 170 / Tram 107/bus 170
»Abzweig Katernberg«

Fuß- und Radweg zum Schacht 3/7/10 Phänomania Erfahrungsfeld [1 km]
Footpath and cycle path to Shaft 3/7/10 "Phänomania" attraction [1 km]

"Take-with-you" or handheld wayfinding-brochures lead visitors along their path and can be referenced as needed. They are regularly updated with event dates and wayfinding directions, and are integrated with painted signals on the ground. Various elements are referenced in the brochure as wayfinding tools, such as personnel stations, 3-D cast-iron miniature models, ground markings, lightened panels, and notable printed media. Also featured in the brochure is a detailed scheme of Zollverein's three core elements of wayfinding: haptic, handheld, and signage symbols.

<<<

Contrary to traditional typography rules, the signage was entirely set in capital letters. Hierarchy was achieved using red as a primary title color, and white and gray as subcolors. The black background is a reference to the site's coal mine past. Parking lot signs are marked with a sector code and a miniature map highlighted in red to help visitors remember where they parked. Signposts were specifically manufactured using gray polished steel with a rectangular section to ease the insertion of panels.

>>>

ZECHE ZOLLVEREIN 73

PARKING GUIDANCE INTERN

TENANTS PANELS

MODELS AT PAVILONS

MAPS

TYPE ON GROUND/RING PROMENADE

HOIUSE NUMBERS DOORBELL PANELS BANNERS

MODELS IN THE AREA

PERIPHERY ENTRANCE TENANTS PANEL RECEPTION

AREA RING PROMENADE AREA DESTINATION

74 ZECHE ZOLLVEREIN

Cast iron, milling, LEDs, and anodizing print are all part of the wayfinding. Combining both low- and high-tech signage in such an extended area placement was crucial to the functionality of the system. The signage uses mainly typographic cues, deploying different weights and colors to establish a hierarchy. The designers took Zollverein's unique topography into consideration and enhanced it as wayfinding elements through illumination. The rest of the signage was specially created with backlit neon elements to avoid interfering with the overall color scheme of the complex.

<<<

ZECHE ZOLLVEREIN

PICTOGRAMS

Pictograms are quick-reference signs or signs of such high importance that designers cannot risk them being wrongly interpreted by nonnative language users. Featuring images of physical objects, their use depends on an impulsive common-to-all interpretation of a visual symbol.

FIRSTDESIGN

The Cologne communication design office FIRSTDESIGN was founded in 1999 by Christopher Ledwig. Lucid in its concepts without being ordinary, the studio's philosophy answers the needs of various fields, ranging from local to national to international clients.

FIRSTDESIGN has grown into a team of communication and industrial designers and architects performing cross-disciplinary projects based on international experience. The studio covers the traditional skills of communication design in 2-D (corporate design, graphics, interface design, editorial design) and 3-D (way-finding systems, fair trade, shop design, packaging). The interdisciplinary team is characterized by cross-media solutions following an analytical design approach.

How did you become involved in the Zollverein project? Did you team up with other companies to compete for the project?

The Zollverein project was a European-wide competition. One of our clients asked us to participate and we gladly did. To be eligible, teams had to be formed by four different companies working in the fields of landscape architecture, lighting design, art, and communication design.

What is the graphics/signage budget for the project? What is the overall budget?

The overall budget for the park is 19,780,000 USD. The graphics/signage budget is 1,005,000 USD.

Who is the client?

LEG, which is a public utility housing enterprise in the fields of property development, facility management, and urban development. LEG is owned in majority by the state of Northrhein-Westfalia. It manages the development for the on-site Entwicklungsgesellschaft Zollverein (Zollverein Development Company).

What was the working relationship like between your company and other design companies on the project team?

We teamed up intensely throughout the whole competition phase. By interweaving disciplines we were able to present harmonious and appropriate site plans. The last two years were great fun altogether. Each one shared their experience enriching the working process.

You said in your competition submission that you wanted to "create a signage system without conventional signs." Why is that?

The Zeche Zollverein is a very unique site. The challenge of the wayfinding system is to answer the needs of five hundred thousand visitors a year while at the same time coping with the strict regulations of the monument conservation. Our design intention is to create a signage system without conventional signs. It is conceived to guide with minimal yet distinctive clues rather than confusing by installing a forest of signs. The keynote is: silent in terms of quantity, loud in terms of quality.

What kind of direction did you receive from the client in terms of the type of graphics/signage system they envisioned for the project?

A starting master plan gave a very rough outline of the client's intention. They were looking for something fresh and new since there was an existing overall signage system that did not work.

What would you say was the biggest challenge of the project?

I guess to try to please everybody. Client, owners on site, institutions, development company, and monument conservation.

With such a huge project area, how did you determine how to break it up into more manageable pieces?

The area was subdivided into functional units and each one was treated separately and successively integrated. We had to plan for areas step by step for design and economic reasons.

The miniature models are wonderful. Why were they so important to your sign system?

They are our haptic way to guide: The miniature representation of the original. The visitors find these miniature-scale casting iron 3-D models of the complete area at all entrances. The huge dimensions become immediately clear, as do the visitors' positions and destinations.

Is there a main entry/identification sign?

No. They are guided by an exterior parking guidance system. The visitors are welcomed by means of the 3-D models.

CORPORATE AND RETAIL

Covering projects that fall into the category of profit organizations and thus including corporate headquarters, banks, and business convention centers, this chapter sheds light on the wide sector of business-related installments and their specific signage needs. The projects in this section emphasize the enhancement of company values and presentation. A classic example is One Raffles Quay, with its massive glass letters indicating the entrance to the complex and a stern arrow system to navigate the organization once the visitor is inside. The trend is to keep alive a decorative feeling without sacrificing operability. Even if the general tendency for signage systems destined for commercial and retail usage is a higher budget, fancy materials, and a more somber approach, there are exceptions. The wayfinding strategy designed by studio Retrovisor, for instance, has an entirely hand-drawn scheme that communicates much more playfulness than seriousness. It might seem counterproductive at first, but one realizes on closer examination that since the design was meant to foster creativity (the building was the headquarters of a renowned advertising agency in Madrid), the playfulness actually means business.

>>>

82 AUSTRALIAN INDUSTRIAL RELATIONS COMMISSION

AUSTRALIAN INDUSTRIAL RELATIONS COMMISSION

Signage scheduling and design were created for the new Australian Industrial Relations Commission court facilities. A stark, elegant signage was chosen in line with the architecture and the philosophy of the building. The signage involved both standard and digital solutions. The project involved the navigation and interpretation of a complex public space and led to the design of "helix"-based signage blades, large-scale environmental graphics, and folded aluminum corporate signage. The overall concept focused on the commission's heritage in a contemporary aesthetic that followed the interior fit-out by Jackson Interiors.

Location: Canberra, Australia
Design team: Soren Luckins/Büro North
Website: www.buronorth.com
Main materials: vinyl, Plexiglas

>>>

Büro North adopted a clever graphical solution for the conference rooms in order to increase privacy and make the decoration a functional way to identify the rooms, thus making decoration part of the signage. The portraits of important Australian businessmen are rendered in black-and-white images. The effect of these projections on sunny days is almost cinematographical; while keeping its shading function, the decoration still manages to create a stunning effect inside the rooms.

<<<

AUSTRALIAN INDUSTRIAL RELATIONS COMMISSION 85

Hearings List Monday, 12 February 2007

11:30 am	Beiziters v Georgia Morgan Designs Pty Ltd	Conference G, Level 6 · Commissioner Foggo
11:30 am	Abdulla v Crown Casino Ltd	Conference F, Level 6 · Commissioner Blair
12 noon	Brincat v The Greenery	Court 3, Level 6 · SDP Acton
12 noon	MEAA-WA - proposed industrial action by employees of the West Australian Ballet	Court 9, Level 5 · SDP Lacy
1:00 pm	Skinner v Manor House Apartments	Conference G, Level 6 · Commissioner Foggo
1:30 pm	Fredrick v APV Automotive Components Pty Ltd	Conference F, Level 6 · Commissioner Blair
2:00 pm	Austin Health v HSU	Court 6, Level 6 · Commissioner Cribb
2:15 pm	Yared, Mr Elsae v Parks Victoria	Court 4, Level 6 · Commissioner Smith
2:15 pm	AFMEPKIU v Skilled Engineering Ltd	Court 5, Level 6 · Commissioner Simmonds
2:15 pm	Harding v Stramit Corporation Pty Limited	Court 6, Level 6 · Commissioner Gay
2:30 pm	CFMEU/Linfox Warehousing Timber and Building Products Award 2003	Court 3, Level 6 · SDP Acton

Please wait. More hearings to follow...

- **L4** Australian Industrial Registry / Public Enquiries
- AIRC Library and Sir Richard Kirby Archives / Access and Enquiries
- **L5** Court 9, 10, 11, 12 / Conference Room A
- **L6** Courts 1, 2, 3, 4, 5, 6, 7, 8 / Conference Rooms B, C, D, E, F, G, H
- **L9**

The court signage is always complemented by information displays keeping the visitor informed at all times. The flat screens are part of a three-dimensional sign that makes them readable in all light conditions. The typographical solution is consistent across both the signage and the digital interface.

>>>

交易廣塲第一、第二座
One & Two Exchange Square

歷山大廈
Alexandra House

CONNECT 12

Ranging over twenty blocks of central Hong Kong, this signage, wayfinding, and branding program links the twelve-building office and retail portfolio of Hong Kong Land Limited into a unified brand statement. The goal of the project was to enhance the appeal of HKL's office buildings and simplify visitor experience by reinforcing the upscale image of the complex throughout the network of pedestrian bridges connecting their properties to nearby transit nodes and adjoining buildings. By making the property portfolio more accessible, the appeal of the buildings was also increased.

Location: Hong Kong, China
Design team: Calori & Vanden-Eynden
Website: www.cvedesign.com
Main materials: vinyl, Plexiglas

>>>

88 | CONNECT 12

Operationally, the project was driven by the bilingual (Chinese and English) needs of the tenants and visitors of HKL's buildings. The HKL logo, combined with the designed signature dot pattern, on all signs forms a wayfinding "ribbon" that knits together the complex pathways and the physical characteristics of the various bridges. The sign program elements include directional, identification, map/informational, and decorative signage. This project was completed in 2002.

<<<

Graphic Band - Type A.1

Text Sign - Type B.1

Text Sign - Type C

Orientation Maps/Directories - Type E.1

Totems - Type F.2

CONNECT 12 89

St. Georg
Chater Road
Alexandra House
Ice House Street
cester
Landmark
rgh Tower
Ice House Street

- ■ Hongkong Land Buildings
- ■ Totems
- ▲ Wall Portfolio Identifiers
- ● Orientation Maps/Directories
- ■ Directional Signs
- ■ Graphic Band

CONNECT 12

SIGN PLACEMENTS-
ALEXANDRA HOUSE
NODAL AREAS

5

The Landmark
2/F
公爵大
置地廣
告羅士

The project evolved over time and eventually included new signage for the Landmark, central Hong Kong's top retail atrium, and the podium spaces of the HKL's Exchange Square office complex. All signs employ the HKL logo and the signature dot pattern. For the Connect 12 signage program, C&VE performed a thorough analysis of circulation routes and nodal points in central Hong Kong's complex network of elevated pedestrian bridges. This diagram is a study of proposed sign locations and types along elevated network pathways and at street-level entry points to the network.

<<<

KREISSPARKASSE LUDWIGSBURG

KREISSPARKASSE LUDWIGSBURG

This project features a conceptual approach to a functional and identity-building guidance system. Small independent savings banks earn their client base and trust on a local basis. Design followed this idea and created a friendly image that clients could relate to. The aesthetics developed for Ludwigsburg could pass as somewhat baroque: vast use of graphics and a generally decorative approach. Nevertheless, it is the architectural characteristic of a 450-foot-long access corridor that dictates sign placement and characteristics.

Location: Ludwigsburg, Germany
Design team: L2M3
Website: www.l2m3.com
Main materials: paint

>>>

KREISSPARKASSE LUDWIGSBURG

As part of its friendly open-to-public policy, the building often hosts public events that usually take place in the main hall. In these occasions the parking garage is open to visitors and the signage system had to take this into account: the staircases are thus highlighted with a different color in order to locate the entrance to the building. An additional, informative layer supplements the perspective signs. In this case the building is depicted with a simplified ground plan, painted white to attract further attention.

<<<

KREISSPARKASSE LUDWIGSBURG 93

Veranstaltung

Colors distinguish between the parking garage levels. Ground markings guide the visitor to the entrance achieving a "connect-the-dots" effect to familiarize the visitors with the premises. Visitor flow was studied closely with the architects before sign placement.

KREISSPARKASSE LUDWIGSBURG

KSK LUDWIGSBURG
SIGNAGE SYSTEM

The letter indicates the building section, while the digit indicates the floor. Extensive studies were made to be able to paint the codes anamorphically. The distorted proportion serves a dual purpose: it makes the sign visible from the ends of the long corridors while giving a sense of projection, aided also by the linear neon lights that run throughout the length of the halls.

KREISSPARKASSE LUDWIGSBURG 95

The long corridor provides access to all areas of the building. The staircase cores are graphically emphasized as important access areas. In the entrance hall, visitors and staff can consult a layout panel to locate the various departments.

>>>

96 KREISSPARKASSE TÜBINGEN

KREISSPARKASSE TÜBINGEN

This signage scheme was developed for the new building of a local bank. The credit union pushes for modern and transparent banking, keeping social, ethical, and ecological ideas in high regard in their mission statement. The wayfinding system was implemented to speed the end-user clearly through the premises but also aimed to express emotion and identity. This was done by making use of all-embracing painted graphics—to give the idea of a compact, reliable entity, and by applying frosted vinyl on the glass walls to convey transparency and service.

Location: Tübingen, Germany
Design team: L2M3
Website: www.l2m3.com
Main materials: vinyl, paint

>>>

KREISSPARKASSE TÜBINGEN

This inside/outside theme is fundamental within the design of the guidance system. Its core is represented by a tree as high as the building itself. This idea, implemented by means of an opaque, heavy-coated paint applied directly on the walls, is a metaphor that emphasizes the company's commitment to clear banking and more ethical and responsible investments. The tree thus creates a bridge to ecological themes and has an impressive scale. It is also a trampoline to the symbols that designate each floor: leaves, insects, butterflies, and birds.

<<<

The vinyl on the glasses also functions as a form of protection against walking into the omnipresent doors and windowpanes. Transparency reflected from the company culture corresponds to an office landscape free of intermediate walls. This is reflected on the signage, which had to be uncluttered and clean. Consequential to this, the studio used sans serif fonts and a three-color scheme—gray, red, and white—in all signage instances.

>>>

100 MÜNCHNER TECHNOLOGIEZENTRUM

MÜNCHNER TECHNOLOGIEZENTRUM

Upon relocation to a new center this business and technology center in Munich needed an advance wayfinding system that would combine digital and graphic-analog elements. The studio decided to couple both traditional and computer-based virtual wayfinding to underline the center's inclination toward new technologies and innovation. Another important characteristic is the central graphical concept: an imagined midpoint sends concentric circles across the building, helping the visitor instinctively find his or her way. This increases the utility and ease of use of the system as a whole.

Location: Munich, Germany
Design team: L2M3
Website: www.l2m3.com
Main materials: paint, virtual

>>>

102 MÜNCHNER TECHNOLOGIEZENTRUM

ABCDEFGHIJ
KLMNOPQRST
UVWXYZ
0123456789

A custom font was created for the project, and it is widely used in all applications of the wayfinding. It is inspired by early CRT screen fonts. This vintage look was chosen to break with the stark modernity of the whole building while not detaching completely from a tech feel.

<<<

MÜNCHNER TECHNOLOGIEZENTRUM 103

There is a touchscreen at the entrance that connects the visitor with the companies. With a few touches one gets to the right firm and gets an overview of the building at the same time. Represented are the four simple steps to follow to locate a company. This solution was arrived at for two reasons. It represents a starting point for the visitors, where they begin the wayfinding experience, and it reduces the need for directional signage and labeling, thus rendering the whole scheme less cluttered.

>>>

104　MÜNCHNER TECHNOLOGIEZENTRUM

The concentric concept, although tricky to interpret at first, becomes clear as the visitor continues his visit throughout the building. The visitor starts recognizing the enamel painted concentric circles in the entrance hall. The different bending defines the distance from the midpoint. The location of vertical signage was accurately studied to integrate with the painted-on solutions and, as indicated above, to avoid excessive cluttering.

<<<

MÜNCHNER TECHNOLOGIEZENTRUM 105

Both typographical and pictogram solutions were used. The custom pictograms were designed continuing the identity of the typeface, by "pixilating" some of their features. The rest of the frosted vinyl applied directly on doors blends with the underlying concept, in an effort to communicate wayfinding in a simple and straightforward way. However much the focus on functionality, a strong decorative essence is also reflected, adding character and beauty to the general architectural context.

OGILVY MADRID

OGILVY MADRID

Ogilvy—a famous advertising agency—commissioned a very special wayfinding task: to develop a system that would inspire creativity without adding too much clutter. The challenge was to take creativity to the second power by contextualizing the signage in the building's activity. To achieve this the designer worked on the concepts of stimulation of creativity, relaxation, and coziness; in short, it was a decorative functionality approach to signage. The result was a cheerful image that keeps its pragmatism. Everything was designed by hand and applied directly on the walls and doors.

Location: Madrid, Spain
Design team: Santiago Morilla, Javier Arcos/Retrovisor and Tropographik.com, Bassat Ogilvy Madrid
Website: www.retrovisor.com
Main materials: paint, vinyl

>>>

While the decorations are ubiquitous and toy with the idea of occupation of the spaces, they also hold a signage function as a quickly recognizable code. Due to the high structural complexity of the interiors, the signage solutions were placed on different surfaces: walls, glass, backlit Plexiglas. More standardized signage coding is used to designate the different rooms but the playful image is achieved through the use of a calligraphic typeface.

<<<

Room signage is often communicated on more levels: here the number 270 is represented typographically and also is the angle it represents. The decorative/iconic signage always has a wayfinding function as directing user flux toward the exits. The designer was instructed not to let the decorative parts exceed into the abstract; all representations are well connected to the areas they represent. Standardized signage was kept into account.

>>>

OGILVY MADRID 109

ONE RAFFLES QUAY

Among Singapore's largest office tower developments, the complex consists of two towers, an 850-space parking facility, a retail arcade, and multiple above- and below-grade connections to the MRT subway and a pedestrian bridge system. To enhance the importance of the construction, the signage had to be dramatic and eye-catching. Basing color scheme on green and orange, and implementing all wayfinding on simple arrow concepts with the added value of backlighting and brightness of its glass, achieved both a spectacular effect and a clear visitor flow through transit areas.

Location: Singapore, Republic of Singapore
Design team: Calori & Vanden-Eynden
Website: www.cvedesign.com
Main materials: light metal alloy

>>>

Detail of the backlit front entrance "sign-fountain." Site identification signs: one consists of 15x40-inch-tall hand-crafted cast glass letters while the other is a forty-inch-high laminated glass letterforms inlaid into stone panels and rear illuminated. The letters are perched on a fountain wall and illuminated from light fittings set below the water's surface.

ONE RAFFLES QUAY 113

The fountain theme is proposed again in the main hall, where a green plaster half-moon ceiling also serves as counterpoint to the building's mechanical perfection and helps bring visibility to the hanging arrow signage. Avoiding useless clutter, the studio decided to place signs on horizontal banners dropping down from the ceiling; the backlit signs help visibility while not hindering repeat visitors.

ONE RAFFLES QUAY

Illuminated totem signs of stainless steel and custom-made pattern glass provide orientation and identification information. Vertical posts were chosen in order to give the impression of columns and represent a fixed reference to visitors, in contrast with the high-roofed architecture. The totems use a black plastic layer as a "stencil" cover to show the backlit typography. As an optical effect of the lighting, letters acquire width. To compensate for this a lighter, narrower version was designed.

ONE RAFFLES QUAY 115

Light and shadow, intentionally designed into the totem signs, played a key role in reinforcing the drama of the building's central podium. The color was chosen to perfectly integrate with a bamboo forest in the foyer.

VIRGINIA BEACH CONVENTION CENTER 117

VIRGINIA BEACH CONVENTION CENTER

This elegant, sophisticated convention center has become an important civic landmark. The building's architectural and interior designs employ subtle references to nautical forms in grand spatial gestures. In the project signage, the studio reinforced these nautical references with sculptural, white sign forms that evoke the shape and form of sails. A clear, hierarchical sign nomenclature system was developed to help visitors effectively navigate the vast lateral distances of the convention center's site and interior spaces.

Location: Virginia Beach, Va., United States
Design team: Calori & Vanden-Eynden
Website: www.cvedesign.com
Main materials: light metal alloy

>>>

118 VIRGINIA BEACH CONVENTION CENTER

This comprehensive sign program consists of a variety of exterior site directional and identification signs, as well as interior directional and identification signs for both public and nonpublic areas. From the outside, opaque white aluminum letters point to the exhibit hall entrances and provide orientation opportunities.

<<<

VIRGINIA BEACH CONVENTION CENTER

The directories carry the exterior sign forms into the interior spaces. Located near all elevators or stairs, the directories provide detailed information at key decisions points. All signage is made of lightweight and durable hard plastic with screen-printed graphics. Large, silver letters were cast in light metal alloy. To further implement the idea of navigation, the letters rest on white metal stands. The sign graphics use a contemporary humanist typeface sized for good legibility at long viewing distances. Pictograms are kept white on white and backlit with light blue neon to enhance contrast.

TYPE SIGNS

Conveying a corporate image is of fundamental importance for signage systems meant for business and retail use. Type signs frequently feature custom typography used to reinforce the overall image of a building or organization. The applications of typefaces frequently relies on paint or vinyl stickers; new and unusual materials are also experimented with today.

← 交易廣場第一、第二座　← One & Two Exchange Square
← 機場快綫　← Airport Express

NORTH TOWER
ONE RAFFLES QUAY

what you show

The Landmark
2/F
公爵大廈
置地廣場
告羅士打

BÜRO NORTH

Established in 2004, Büro North is a multidisciplinary design practice delivering evidence-based solutions that are creative, measurable, and meaningful. Led by Design Director Soren Luckins and Wayfinding Director Finn Butler, Büro North's diverse team works across the disciplines of graphic design, industrial design, and wayfinding. With an unwavering commitment to quality, Büro North's design and strategy work in tandem in the creation of products, brands, identities, publications, signage, environmental graphics, and wayfinding.

Büro North's approach is to discover the absolute potential of a project and to resolve their clients' design and communication issues with mature rigor and creativity. A team of ten people brings members' individual ideas and concepts to the table for all projects.

Do you work closely with the architects/interior designers? Do you find these collaborations time-consuming or inspiring?

We view collaboration as the precursor to good design. The urban environment demands a visual language that is easily understood. As designers, we strive to achieve the highest level of environmental literacy and are cognizant that best results arrive from a synergy of disciplines. Büro North's key strength resides in the diversity of talents represented within our multidisciplinary team, including several renowned wayfinding specialists. We also embrace the opportunity to collaborate with other like-minded professionals such as architects and interior designers. Ultimately we are all working for the best result for our clients.

What kind of clients do you usually work with? Large corporate? Cultural entities?

Our clients vary from large corporations to small boutique developers, new businesses and other design practitioners. We are conscious of our community and are also involved with charity projects such as Head Case. We approach all clients and projects with the same enthusiasm and unwavering commitment to produce the optimum result for them.

Do you develop the signage system around a unique concept or do you rather follow a series of aesthetic choices?

We develop the concepts directly from the Wayfinding Strategy. We usually like to layer ideas to develop a richness and depth to the work, and then reduce the concept down to maximize the impact and distill the complexity so the final design appears quite simple.

What are your main sources of inspiration? What past designers/studios do you refer the most to?

Sources of inspiration come from every angle; we are particularly interested in architecture, art, science, and the natural environment. Designers of note who inspire us range from Dieter Rams, Joseph Muller Brockmann, Jonathon Ive, and Konstantin Grcic to Stefan Sagmeister.

What kind of brief do you usually receive from the client? Do you work with very specific directions, or are do you enjoy freer terms of work?

We not only act as designers, but also play an integrated strategic role in developing our clients businesses. No client or project is alike and so we approach every brief with a unique perspective. In partnering with our clients, we develop creative, measureable, and meaningful three-dimensional outcomes, informed by visual, emotional, functional, and cultural inputs. A delicate balance exists between marketing, manufacturing, and environmental and financial imperatives to best optimize design, and we use evidence-based design principles to facilitate this process.

What would you say was the biggest challenge in creating wayfinding systems?
Understanding the client's operational requirements and business objectives, and understanding how their users will intuitively want to use the space. Once both of these are understood then a strategy that deals with those specific details can be successfully developed.
We extensively research every aspect of the area and measure up the most productive and effective strategy to understand what the users of the area will require and how it will interact with the surrounding environment.

Do you follow the entire production by yourselves? Do you commission work or install some parts yourselves?

Büro North appoints a team leader to all projects that come into our office. The team leader and our directors follow these projects carefully from start to finish. When working with other companies/individuals we embrace their knowledge and combine both parties' talent and skills to produce the highest quality of work for our clients.

Where do you think the future of wayfinding lies? New technologies (e.g., remote terminals, BlackBerry, iPhones, mediated wayfinding, etc.) ?

I think the future of wayfinding lies in coordinated multidimensional information delivery. The same system, information hierarchy, graphic user interface, and visual tools will be delivered in different mediums. Information kiosks will coordinate with fixed signage and mobile technology such as iPhones.

CIVIC AND HEALTH CARE

This chapter comprises projects that are publicly funded or are related to local authorities (schools, civic centers, academies) or health care and clinics. Also, most hospitals are large complexes and they usually consist of different structures developed at different times. Coordination between medical units, maximum sign visibility, and integration between outside and inside signage are only a few of the difficult and at the same time exciting challenges that these multifaceted structures pose for wayfinding specialists. One of the most notable examples is the Tulln clinic. The building is a behemoth construction of five floors and five departments, with external and internal parking lots adding to its complexity. The project would have been virtually impracticable without a well-designed strategy. The clinic's signage system is a perfect model of the implementation of quick-access nonverbal codes such as color and made-to-order pictograms, directional design, and typographical information. The modernity and dedication to flux organization of this scheme synthesizes all other projects in this chapter—hospital wayfinding systems are the race cars of the field.

>>>

Billund Airport

abcdefghijklmnopqrstuvwxyzæøå
ABCDEFGHIJKLMNOPQRSTUVWXYZÆØÅ
1234567890 !@.;&+-(%)#?

abcdefghijklmnopqrstuvwxyzæøå
ABCDEFGHIJKLMNOPQRSTUVWXYZÆØÅ
1234567890 !@.;&+-(%)#?

abcdefghijklmnopqrstuvwxyzæøå
ABCDEFGHIJKLMNOPQRSTUVWXYZÆØÅ
1234567890 !@.;&+-(%)#?

BILLUND LUFTHAVN

The opening of the new terminal coincided with the presentation of a comprehensive new signage system. The branding is the result of years of intensive cooperation with Billund Airport and comprises an extension of the business concept to include a vision, mission statement, and set of core values. A communication platform has also been devised that positions the core values in relation to the communication tasks determined by the users. The design program includes a new name and a new set of basic visual elements: a logo, unique corporate typeface, and the color scheme.

Location: Billund, Denmark
Design team: Kontrapunkt
Website: www.kontrapunkt.com
Main materials: printed metal

>>>

Airline 1234

The electronic signs satisfy the airport's need for dynamic signs that can be quickly updated or changed. The airport makes extensive use of written communication on signs, uniforms, and interior decoration. Using the custom font gives every written message a clear brand signal, even when the logo does not appear. Billund Airport has two primary brand colors: yellow and dark gray. The color yellow represents both continuity and innovation and is a direct reference to the bee, which is its mascot symbol.

The font has been developed and tested for maximum legibility in all media. Its expression is simple, functional, and at the same time appealing. The dark gray and blue reflects the airport architecture and helps the signs and other furnishings to blend in naturally with the airport interior. The outdoor signs are in glass, aluminum, steel, and birch veneer. The shapes and materials of the signs were chosen to complement the counters and to harmonize with the other interior furnishings at the airport.

KANTONSSCHULE OERLIKON

To design a suitable signage for this cantonal school, the designers felt it was important to find a contemporary answer to complement the 1970s atmosphere of the building. In order not to disturb the simple and clear structure of the building, the use of mountings or fixtures was avoided. The typeface—which was directly applied to the walls, doors, and exterior of the building—has a very strong degree of functionality. It grows in weight to indicate the floor and it works perfectly on the gray bare concrete walls and on the directories.

Location: Zürich, Switzerland
Design team: Bringilf Irion Vögeli
Website: www.bivgrafik.ch
Main materials: paint, metal

>>>

KANTONSSCHULE OERLIKON

AUDITORIUM
MEDIOTHEK
MENSA

0123456789
0123456789
0123456789
0123456789
0123456789

ABCDEFGHIJKLMNOPQRSTUVWXYZ
ABCDEFGHIJKLMNOPQRSTUVWXYZ
ABCDEFGHIJKLMNOPQRSTUVWXYZ
ABCDEFGHIJKLMNOPQRSTUVWXYZ
ABCDEFGHIJKLMNOPQRSTUVWXYZ
ABCDEFGHIJKLMNOPQRSTUVWXYZ

The font is exclusively designed for this project and it is its most prominent feature. While retaining a rigorous and stern feeling, it blends perfectly within the overall redesign concept of the signage system with its rounded angles and repetitive concept. The font is used both externally and internally, reinforcing the school's identity. Thanks to its concentric nature the typeface is well readable from any distance.

<<<

ERÖFFNUNG
KANTONSSCHULE
ZÜRICH BIRCH

The font was also designed to contrast well in all the colors used for the palette. The different weights also serve a practical function: the heavier the typeface weight, the lower the floor. Any room located on the floor will be written with the same weight. This is an essential reference in a building this big, where it's easy to forget what floor one is on. Moreover, this play of concentric forms adds an upward progression and a visual dimension to the letterforms.

>>>

134　KANTONSSCHULE OERLIKON

Adopting only one typeface is not only aesthetic but also cost-effective. Concentric outlines increase point size and facilitate the screen-printing process. At low point sizes the typeface becomes a direct rounded font that still retains high legibility. It has been objected that a cantonal school should have a more colorful approach to signage, but once implemented it was clear how the gray is the best choice to deliver the service message without interfering with the existing 1970s structure.

<<<

KANTONSSCHULE OERLIKON 135

Black metal alloy boxes with white cardboard interchangeable signs make up the library signage, which was specifically designed to blend in and resemble the books. All labels are also number-coded for clarity. The staff can add flexibility to the system by printing cardboard templates.

>>>

136 LANDRATSAMT TÜBINGEN

LANDRATSAMT TÜBINGEN

This governmental building needed a strong, communicative signage system focusing on the interface between the public and the administration. The idea was thus to provide guidance while trying to communicate friendliness. This is achieved mostly by means of a customized "dot" font and painted signs, not always in customary places. Other features are vertical metal column posts and a lime and pastel color scheme. The overall result is a modern wayfinding system that is welcoming while never compromising the needed austere environment.

Location: Tübingen, Germany
Design team: L2M3
Website: www.l2m3.com
Main materials: paint, metal

Motor vehicle licencing office

>>>

138 LANDRATSAMT TÜBINGEN

The ceiling graphic at the main entrance presents all communities of the Tübingen county, their distance to the building, and their number of inhabitants. Parts of the typography and pictograms are converted into a dot matrix. A near-and-far effect appears. Up close the letterforms seem to disappear. They recompose and become legible from a distance.

LANDRATSAMT TÜBINGEN 139

Information identifiers were totem signs approximately six feet tall with screen-printed graphics directly on the metal. The enamel lime green paint—chosen for its neutral tone—contrasts well with the gray and reinforces the flat metal surface. To avoid excessive repetition of totems signs, they were placed in the middle of the rooms, with bleed-out graphics to give the impression of expanding into the surrounding space. The dot font is used here with a smaller matrix to reinforce color appearance.

140 DRÄGER MEDICAL

DRÄGER MEDICAL

This office building is a glazed structure that twists and turns, ribbonlike, around courtyards and pathways. All the external walls and the internal walls facing the atrium are fitted with glass: this transparency makes it easy for visitors to identify where they are with reference to the interior and exterior of the building. The wayfinding system consists of a base motif modulated in six variations. At its core it is a simple, grid-style pattern of rings that is different on each floor. Several variations of the base theme satisfy all different signage needs.

Location: Lübeck, Germany
Design team: Büro Uebele
Website: www.uebele.com
Main materials: vinyl, glass

>>>

142 DRÄGER MEDICAL

The material used has an incorporeal quality: the architecture and its environment are mirrored in the highly reflective film, appearing as a light, mobile, and shimmering image in the slender rings and circle shapes. Visually a circle is a strong shape: self-delimiting, self-referential. Text fitting with this form becomes challenging when other, noncircular elements come into play. In line with the circle's visual rules, type is aligned with a central axis that relates to the symmetry of the ring. Use of block capitals evens out the marginal spaces, calming the overall visual effect.

<<<

DRÄGER MEDICAL 143

The codes for different rooms, levels, and sections of the building are displayed within these circles. The pattern shapes are nondirectional and nonprescriptive. The spacing of the rings varies in two directions, creating gaps, clusters, and distinctive formations. Graphic symbols cover the internal glass walls, helping define the different location moods. The information is incorporated within the pattern, by filling in rings to create surfaces. They overlay the glazed walls like a transparent net curtain, preventing people from walking into the glass.

>>>

144 FAIRFIELD CITY COUNCIL

FAIRFIELD CITY COUNCIL

This comprehensive graphical and typographical signage and wayfinding solution was designed as part of a comprehensive program of identity for the Fairfield City Council. The objective was to create an integrated solution to be used throughout the city's civic installations, such as sport centers, parks, libraries, and civic centers. The system includes a wide variety of pictograms and a specifically designed font. All of the design process was done in close collaboration with the architectural and interior design teams that developed the various buildings.

Location: Fairfield, Australia
Design team: There
Website: www.there.com.au
Main materials: vinyl, Plexiglas

>>>

146 FAIRFIELD CITY COUNCIL

The project stressed the importance of making the entire city council friendly to nonnative English speakers. Thus an extensive array of pictograms was created. The city center signage creates an informative level to achieve a quick response from users. The stylized "man shape" is a recurring theme throughout the council and it is often used as to introduce larger than usual typographic signs.

<<<

FAIRFIELD CITY COUNCIL 147

(CABRAVALE CUSTOM TYPEFACE)

Cabrava
Leis

01 TYPEFA

Light &
Medium
1234567890
¡™!@#$%^&*)

Working with Fairfield City Council and Prior Cheney Architects, to bring a playful personality and all-embracing environment to the multi-cultural and multi-lingual audience.

Often the pictogram signs are visually supported by the custom font Cabravale Medium. The font was specifically designed to complement the rounded shapes of the pictograms and it can be seen as a typographic pictogram. It adds to the general playfulness of the signage. White and gray vinyl stickers can be seen on the entrances of several city buildings.

148 FAIRFIELD CITY COUNCIL

The recognizable leaf shape is ubiquitous and is a key part of the clarity of the signage system. The visitor quickly associates its form with an indication or an information sign. The wayfinding and sign scheme was used throughout the city, so materials used were very different: the main ones were clear Plexiglas, embossed plastic, laser-engraved metal boxes, and glass stencils.

<<<

FAIRFIELD CITY COUNCIL 149

As a last way of "squeezing" every function out of the extensive pictogram design, Studio There decided to cover an entire wall with a composed image of culturally diverse children. Apart from representing fully the spirit of Fairfield City, the solution is economic and original. The sign was screen-printed on a large vinyl and applied like a wallpaper.

>>>

150 LANDESKLINIKUM DONAUREGION TULLN

LANDESKLINIKUM DONAUREGION TULLN

This hospital was equipped with a modern signage system as part of a new development plan for southern Austria. The design studio coordinated all aspects of the plan, including creating uniform easy-to-read typography connected with the surrounding architectural structures, and a consistent route configuration ranging from the highway up to the patient rooms. Color-coding is also a central part of the system. It is used as a clear way to represent medical departments, emergency rooms, clinical facilities, and intensive-care units.

Location: Tulln, Austria
Design team: Erwin Bauer
Website: www.erwinbauer.com
Main materials: paint

>>>

152 LANDESKLINIKUM DONAUREGION TULLN

Verkehrsschilder | Höhe: 8 m bis zu 200 m Sichtweite | Informationsstele – Gelände Grenze Höhe: 3,5 m 8 – 50 m Sichtweite | Informationsstele – Gelände innen Höhe: 2 m 0 – 8 m Sichtweite | Lageplan

1 Start Region — 2 – Stadtraum — 3 – Gelände — 4 – Eingang — 5 – Information

The main landmark sign—standing almost thirty feet high—derives its shape from the DNA double helix. A transparent metal net covers the entire sign and lighting at night, diffusing light and making the sign instantly recognizable.
In order for the visitors to intuitively find where they need to go, a simplified 3-D model of the area is used on outside maps. They feature the existence and quality of recognizable physical elements of the building, including on-site personnel stations, service stations, environmental spaces and shapes, and visuals building marks.

<<<

LANDESKLINIKUM DONAUREGION TULLN 153

Wandrichtungswegweiser zu Ambulanzen, Stationen, etc. Lifttafeln, Leittafeln Stationseingang Überkopfschild Ambulanz/Zimmer etc.

6 – Weiterleitung 7 – Internes Leitsystem 8 – Ziel Ambulanz/Zimmer etc.

General direction signposts and guides are color coded. Each code is also found in the hospital's visitor guidebook and on building maps. The color gray was purposefully chosen as a neutral color for staff-only rooms. Floor directories made of screen-printed Perspex are found on all entrances and are used on both sides of the doors. The underscore symbol (_) is used to help readability and lessen the need for space.

>>>

154 LANDESKLINIKUM DONAUREGION TULLN

Color was used consistently across all applications. This created a direct visitor reaction to color, which is perceived quicker than interpreting symbols (arrows, pictograms) or reading text. Effective color-coding increases the chance of the user making the right response to visual cues. To keep the appearance as simplified as possible, either black or white font colors were used.

<<<

LANDESKLINIKUM DONAUREGION TULLN 155

All wall signs are positioned in the line of sight of an average person's height. Arrows are drawn at 0 or 45 degrees with respect to the wall line. Extensive chromatic studies were carried out to determine how different colors evoke different reactions. Intensive care was marked red for urgency. Yellow was used in the emergency room to convey a state of readiness. A "soothing blue" was used to designate bedding floors. To avoid alignment problems between the different panels that make up the wall, the signs were placed on the walls successively.

The Tulln facility features experimental symbol families within the psychiatric ward. Psychotherapy is represented by musical instruments, social psychiatry by fruits and vegetables, and child and youth psychiatry by animals.

The signage in the psychiatric ward is applied with the use of vinyl. The representations of the different categories were made through silhouettes. This eased recognition by patients and became a sort of intuitive graphical wayfinding scheme. The many rooms in the ward are numbered, but staff found it increasingly easier to direct patients to the "apple" or "violin" room instead of communicating the number. On glass walls, the vinyl serves as a warning for large glass areas.

LANDESKLINIKUM DONAUREGION TULLN 157

158　LANDESKLINIKUM DONAUREGION TULLN

> Doors and entrances of the entire complex were also number- and color-coded to ease patient and doctor circulation. Lighting and lighting placement options were thoroughly studied to attract attention to the wall signs. In the cases where the directories had to contain more information than they could easily hold, they were supplemented with a parallel totem. This solution saved the need for a different-size sign and thus lowered production costs.
>
> <<<

LANDESKLINIKUM DONAUREGION TULLN 159

The multi-story parking lot adjacent to the clinical center area also follows the color system, but works with its own numbering system. The arrows are painted higher here because the designers took into account the additional height of the paramedics driving ambulances. It has been proven that users react to light cues when deciding where to move, and so lighting here was specifically intended to follow wayfinding in ease the proper direction of vehicles.

>>>

GEMEINDEVERWALTUNGSZENTRUM AFFOLTERN AM ALBIS

The building has a transparent body, with glass as a central theme. The signage accentuated this characteristic by means of a contrast between the typography and the various parts. The choice of materials was limited to glass and metal. However, by careful choice of color and strategic sign placement the designers achieved an integration so complete that it's now hard to imagine the building without its signage system. The custom font, studied to be highly visible on transparent surfaces, is a key element and an added value with regards to the identity of the building.

Location: Affoltern am Albis, Switzerland
Design team: Bringilf Irion Vögeli
Website: www.bivgrafik.ch
Main materials: vinyl, paint

>>>

ABCDE
KLMNO
TUVWX
12345

GEMEINDEVERWALTUNGSZENTRUM AFFOLTERN AM ALBIS 163

The Albis font was specifically developed and customized for the needs of this project. It is conceived to define and highlight clear areas on glass walls and doors. Thanks to its rounded shapes it works harmonically on different substrates and at different point sizes.

<<<

GEMEINDEVERWALTUNGSZENTRUM AFFOLTERN AM ALBIS 165

The color palette was studied specifically to achieve high contrast while remaining soothing to the eye by use of lighter hues of primary colors. The typeface's marked lines and the stark contrast of its spaces create a clear dialogue with the transparency of the glass and thus with the entire building. While bold and clear, the glass stencils stay out of direct sight, thus allowing the building's glass windows to make full use of natural light.

Many of the rooms are destined for various uses throughout the year, and thus there was a need for a very flexible signage system. This was solved through the use of a modular system of labeling. The rooms can be reconfigured easily and their respective directory signs changed accordingly. Color-wise, the colorful labeling system reads perfectly in contrast with the rough cement walls of the staircases.

Militärakademie an der ETH Zürich

MILITÄRAKADEMIE AN DER ETH ZÜRICH

This ambitious reconversion project needed a contemporary and modular signage system to serve its high needs for flexibility. The conversion of three buildings within the barracks complex revitalizes the atmosphere, light, and color of the interiors. The studio chose to follow and complement this change with a highly interchangeable signage system. The peculiarity of the signage is in fact the ease with which the different room numbers can be labeled through a system of individual letters and metal bars.

Location: Birmensdorf, Switzerland
Design team: Bringilf Irion Vögeli
Website: www.bivgrafik.ch
Main materials: aluminum

>>>

168 MILITÄRAKADEMIE AN DER ETH ZÜRICH

The frequently changing usage of the rooms required a high degree of flexibility. The door labels are constructed using lasered aluminum letters, which slot into a tracked holding plate. The orientation is thus defined by using the room numbers to form the only constant element within the signage. The modifications can be done by hand and require no special tools. The production was a special adaptation of industrial labeling and was entirely supervised by the studio.

<<<

MILITÄRAKADEMIE AN DER ETH ZÜRICH 169

The signs are reproduced as large aluminum numbers that are fixed directly onto the doors. The monospace font gives the signage scheme a clear look and guarantees a similar size whatever the number. To integrate in the atmosphere of the center, the signage closely resembles military rank badges. Directories follow the same concept as the door identifiers: clear, austere, and easily interchangeable.

>>>

OFFENES KULTURHAUS OBERÖSTERREICH

As part of a cultural reconversion, the municipality of Linz launched this ambitious center with two exhibition spaces, restaurant facilities, offices, and a large square in the historical part of town. Historical substance was preserved and rehabilitated in one multifunctional complex, and the signage system was made accordingly. Oxidized metal signs are reserved for outside solutions, and bright plastic signs are used indoors to create an interplay of material and highlight the contrast of traditional versus modern, outdoors versus indoors and raw versus refined.

Location: Linz, Austria
Design team: Erwin Bauer
Website: www.erwinbauer.com
Main materials: rusting metal, plastic

>>>

172 OFFENES KULTURHAUS OBERÖSTERREICH

The emphasis given by the different finishes dissociates the signage from the classic metal letter, while the identity is kept strong by custom typography and pictograms. The stenciled and slightly raised numbers also have the characteristic to create a natural shadow on sunny days. The arrow signage keeps the same proportion as the letters and numerals and can be seen as part of the typography to create uniformity in the typographic signs.

<<<

OFFENES KULTURHAUS OBERÖSTERREICH 173

The system formed by punched and painted metal plates works well in both internal and external locations. The stencil theme is ever-present in both pictograms and fonts. It conveys the message as negative space and adapts to the background color, which is both cost-effective and aesthetic. Regarding color scheme, internally a white and gray was preferred to go along with the raw interiors while using rusting steel and black in the square to blend in with the surroundings there.

174 TEXAS MEDICAL CENTER

TEXAS MEDICAL CENTER

With more than forty member institutions located on a densely developed 32,000-square-foot area, the TMC is the world's largest medical center. And with more than twelve miles of streets and roadways—and approximately forty-three thousand parking spaces—it presents some significant wayfinding challenges. A comprehensive wayfinding strategy was called for, with design ranging from roadside signs, to signposts, to interactive and virtual wayfinding schemes. The studio also had the responsibility to implement all wayfinding components, construction documentation, and supervision of all fabrication and installation.

Location: Houston, Texas, United States
Design team: f2ds
Website: www.fd2s.com
Main materials: metal plates

>>>

TEXAS MEDICAL CENTER

Vehicular wayfinding signage within the Medical Center directs users from the numbered entrance to their destination. Street identification signage is also part of the system, reinforcing the idea of the Medical Center as a distinct place. The system's details reflect the need for expandability/modularity, as well as the Medical Center's position as a world-class health-care campus.

<<<

All parts of the signage system were custom made. Aluminum alloy modular signposts, plastic screen-printed maps, and enameled metal plates complete the main entrance signs, made of clear Plexiglas backlit for nighttime vision. Pedestrian wayfinding elements represent a curious detail, as they utilize a unique mapping style made of zoomed-in enhanced areas. This peculiarity helps simplify the dense campus.

>>>

TEXAS MEDICAL CENTER 177

178 TEXAS MEDICAL CENTER

The new wayfinding website is one of the first of its kind to be based on Google Maps, which adds functionality and simplifies updates. The welcome screen gives users the choice of entering their destination directly or selecting from a destination list. Also, after entering a starting point, users get detailed driving directions and a customized location map showing their destination.

<<<

TEXAS MEDICAL CENTER 179

Signalized Intersection
Signal Arm-Mounted Street Identification

ST 11.0
Intersection Directional

ST 2.0
Institution ID: Primary

ST 3.0
Vehicular Directional: Primary

ST 2.1
Institution ID: Secondary

ST 4.0
Vehicular Directional: Secondary

ST 5.0
Pedestrian Directional

ST 5.1
Pedestrian Directory

Non-Signalized Intersection
Street ID and Regulatory Info

ST 1.0
Primary Campus ID

The comprehensive rendering of the wayfinding scheme shows how vehicular wayfinding elements on roadways lead users to the appropriate numbered entrance. Numbered entrance monuments include the names of destinations served by that entrance.

>>>

ST 3.0.1
Numbered Entry Marker

ARROWS

The quintessential wayfinding graphic tool is the arrow. Conveying direction, orientation, and the intensity of the sign, arrows make sure that end-users feel there is a wayfinding scheme in action. Nowadays, arrows tend to be overlooked in favor of new graphic symbols, but they remain critical when designers approach wayfinding in large, complex spaces such as hospitals and civic buildings.

BÜRO UEBELE

Andreas Uebele studied architecture and urban planning at the University of Stuttgart, and graphic design at the Stuttgart State Academy of Art and Design. He has managed his own visual communications agency since 1995, while holding a communications design chair at Düsseldorf University of Applied Sciences. He is a member of Alliance Graphique Internationale, the Art Directors Club of New York, and the German Design council, among other organizations.

The agency focuses on CD/CI, signage and wayfinding systems, corporate communications, and exhibition. Projects are handled by small interdisciplinary teams comprising communications designers, media engineers, and architects. The work of the office has been recognized with more than 250 international awards and is represented in international collections and museums.

Please tell me a little bit about your studio. What types of design work do you do? Is wayfinding the most prominent field of expertise or do you also specialize in other types of design? How many people are in your firm?

In our office the most prominent fields of expertise are corporate design and signage systems. Editorial, poster, exhibition design, as well as three-dimensional design are further tasks that we accomplish. At the moment our studio counts twelve contributors.

Do you work closely with the architects/interior designers? Do you find these collaborations time-consuming or inspiring?

The collaboration with interior designers, architects, artists, and philosophers is a valuable one. These collaborations need to take place at an early stage of every new project.

What kind of clients do you usually work with? Large corporate? Cultural entities?

We have a wide range of clients, from large to small, from public to private.

Do you develop the signage system around a unique concept or do you rather follow a series of aesthetic choices?

We react to the site, the company, and the architecture or to functional terms and conditions and develop aesthetic concepts out of it.

What are your main sources of inspiration? What past designers/studios do you refer the most to?

One doesn't need a main source of inspiration. Tasks that are encountered at the beginning of a project usually define a question, and if you "listen" to them closely, they will contain the answer and convey the meaning that will help shape your solution. Ideals and idealists are a different matter—Otl Aicher, Paul Rand, Anton Stankowski are landmark designers who serve as constant referrals in our work.

What would you say was the biggest challenge in creating wayfinding systems?

The biggest challenge in creating a signage system was the technical realization of two colors on a surface for the project Trade Fair Stuttgart. This sounds quite easy, but it has been a highly demanding technical development in collaboration with 3M; it took more than a year.

Do you follow the entire production by yourselves? Did you commission work or install some parts yourselves?

We supervise the production. The production as well as the assembly are invited to tender for the carrying out and assigned to appropriate firms.

Do you also curate the print and Web communication for the projects?

We usually let another studio do the graphic design that complements the project to our specifications, but sometimes we carry it out ourselves.

Where do you think the future of wayfinding lies? New technologies (e.g., remote terminals, BlackBerry, iPhones, mediated wayfinding)?

The technologies you have mentioned (BlackBerry, iPhone) are a supplement to navigation systems and flyers and are indeed functional in public spaces. Nevertheless, in my opinion, these applications won't be needed inside buildings. Indeed, it is a growing field and the development of other digital technologies will be ever more necessary in tomorrow's world.

PUBLIC SPACES

This chapter explores unrestricted spaces that are either open-air, such as parks, fair spaces, and recreational areas, or indoor areas such as spas and gymnasiums. We decided to include the two latter in this section because, although they could be seen as civic or corporate installations, their most prominent aspect is that of being a space where many people collect. With considerable larger spaces and public accessibility, these projects have been implemented with a number of factors in mind. First, the environment that these signage systems have to comply with is in most cases open-air and publicly accessible. This requires the signage to be climate resistant and made of stronger materials in order to withstand everyday wear-and-tear. Thus the chapter includes the most diverse array of fabrication techniques and heterogeneous signage substrates. Second, the absence of walls also poses the challenge of creating not only the sign but also its support. This is also important when considering the amount of signage. Interesting solutions have been devised in order to contain budgets and to keep the scheme as usable as possible while avoiding excessive clutter or "signpost forests."

>>>

186 BALLAST POINT PARK

BALLAST POINT PARK

Occupying a former industrial site, the park's past as a location of industry and trade is reflected throughout the design by an interesting and engaging interpretive and information system. The signage uses a brown-tone color palette, and stencil typeface to recall the original urban destination. All aspects are utilitarian and functional, unadorned and factory-like yet contemporary. The dot typeface reflects the thousands of rivets and circular tank shapes covering the former park. The gunmetal gray and precast concrete elements used throughout the site parallels the pre-existing tanks and industrial remnants.

Location: Sydney, Australia
Design team: Bruce Slorac, Emerson Wilshier, Maggie Tang/Deuce
Website: www.deucedesign.com.au
Main materials: vitreous enamel panels, sand-blasted walls, router-cut steel panels

>>>

188 BALLAST POINT PARK

Metal columns feature maps and quick-access information and blend with the general color scheme. Part of the signage is used to inform visitors on the past of the park. Vinyl are placed directly on the walls but were arranged in order to not be too intrusive.

BALLAST POINT PARK 189

The architecture studio that was appointed to Ballast Point Park's renovation left many areas of the park bare; the signage tries to blend in and be unobtrusive as possible to respect the aura of the site. The "dot" concept used in the typeface design was also used to design some of the pictograms in order to obtain a coherent effect on the signage. On concrete walls, the option was to stencil or paint the font, but instead the signs and decorative texts were carved to give the feeling of longevity.

flussbad
tiefe 1.35 m
temperatur 30-32

aussenbecken sole

tiefe 1.35 m

temperatur 33-35°

solegehalt < 4%

BERNAQUA

This signage and wayfinding system for Bernaqua—a new and modern fitness and spa club—required designers to bear in mind all the main architectural characteristics of the building, including its dominant color scheme, the lack of orthogonal structures, and its strong dialogue with the external landscape by means of tall glass walls. The solution managed to implement all of these features by developing a customized font, designing an array of pictograms, and combining direction signage and typographic indications at strategic places throughout the premises.

Location: Bern, Switzerland
Design team: L2M3
Website: www.l2m3.com
Main materials: vinyl, paint

>>>

↖ fitness
römisch-irisch
sauna
spa/thalasso

← fitness
römisch-irisch
sauna
spa/thalasso

↑ fitness
römisch-irisch
sauna
spa/thalasso

↙ fitness
römisch-irisch
sauna
spa/thalasso

af m

Both the custom font and the arrow design were made to match Bernaqua's irregular lines and structural angles. The custom font was rounded in order to communicate a more relaxed atmosphere. Instead of adding clutter by using an array of font weights, the designers relied on differences in leading to establish hierarchy.

odule text

1234567890
abcdefghijklm
nopqrstuvwxyz

flussbad
tiefe 1.35 m
temperatur 30–32°

sauna gemischt

wildwassercanyon
kinderbad
solarium
bistro
ausgang
wc

All typography is set in lowercase to enhance the friendly and relaxed tone of the signage. Following anamorphic ideas, the signage can be seen from different angles. This is done not only to achieve an original feel, but also because it is necessary due to the irregularity of the Bernaqua building structure. To align typographic signage with existing structures, arrows and letters were made three-dimensional and apposed onto passageways and doors in order to be as visible as possible.

Lighting is kept at a minimum to be uphold architect standards; the huge glass windows ensure intense natural light during the day. To compensate for this, high-contrast colors had to be employed. Moreover, color scheme was restricted to black and white to respect the wide chromatic range already present in the architecture. Due to architectural and interior design choice, door handles are absent. Hence signage had to indicate door-opening direction by means of vertical and horizontal indicator stripes.

polarlicht

dampfbad
feuchtigkeit 100%
temperatur 45°

bad
wc

ruheraum

196 FALLS CREEK

FALLS CREEK

Falls Creek is a mountain and ski location that resorted to an integrated wayfinding solution to face an increase in visitor flux. The strategy simplified many of the typical pedestrian journeys within the village by formalization of existing vertical access routes. These routes were designed to create logical and more efficient pathways to provide a better fit with people's innate navigational strategies and an alternative to the complex arrivals and departures experience during the winter months.

Location: Falls Creek, Australia
Design team: Soren Luckins, Tom Allnutt, David Williamson/Büro North
Website: www.buronorth.com
Main materials: cast metal alloy, plastic

>>>

198 FALLS CREEK

Büro North devised a solution that is extremely sensitive to the manufacturing, transport, energy, and emissions impacts. The entire signage scheme features a modular system of rotoformed, recyclable plastic structure components that fit around a standard street pole. The casting process was carried out entirely by hand. Schiavello—a professional metal manufacturer—cast the alloy modular components at Mullholland Foundry.

The entire system can be assembled and disassembled on site, reducing heavy transportation costs. These modules hold replaceable information panels that can be seasonally changed with efficiency. The lighting system is integrated in the posts for efficiency and for aesthetic reasons.

FATHER COLLINS PARK

The park features five 50-kilowatt wind turbines that help power all of the park systems and are estimated to save 320 tons of CO_2 per annum. A classic approach to wayfinding was used yet it also combined very contemporary technical solutions regarding materials and engraving techniques. This mix of old and new reflects the dualistic nature of the rehabilitation, rooted in the Irish tradition. The signage fully integrates with the surroundings of the park, using laser-cut stainless steel as a main statement of durability in time.

Location: Dublin, Ireland
Design team: Detail
Website: www.detail.ie
Main materials: aluminum and stainless-steel panels with steel laser-cut lettering

>>>

202 FATHER COLLINS PARK

The entrance monolith sign's lettering was laser-cut and wrapped around but raised off the black concrete plinth. The entrance signs were laser-cut and affixed to granite stone walls on the east and west park entrances. In both occasions stainless steel was chosen to parallel aesthetically with the wind turbines and convey the message of longevity. Wayfinding signs at the entrance to Father Collins Park highlight rules and regulations in dual language, English and Irish, as well as positioning the features and facilities.

FATHER COLLINS PARK 203

The signage is also conceived to locate facilities such as the skate park, playgrounds, and health stations. The information signs are located at key points around the park, providing information about specific aspects, like the ancient hedgerows or wind turbines (sometimes themselves used as signposts). The signs are strategically placed here on the one-mile circuit track, which runs around the perimeter of the park. The signs also act as markers, breaking the route down to 328-yard sections.

ENTERANCE
エントランス

3F
2F

ENTRANCE
エントランス

LOUNGE
ラウンジ

SHOP

OSSO MINAMISUNA

This sign design was conceived for a spa and fitness club in central Tokyo. The designer's approach was to maintain a straightforward approach to signage and wayfinding. The plain and immediate mix of iconic and typographical signage points the way for visitors at first glance. The pictograms were designed while keeping body proportion in mind: the underlying concept of the signage is good health and physical form. The wayfinding was formed to be discreet while improving the quality of the whole space.

Location: Tokiyo, Japan
Design team: Akihiro Kumagaya
Website: http://alekole.jp
Main materials: printed aluminum

>>>

Signs were mounted on black or white square slabs of Plexiglas. The repetition of the square form throughout the sign scheme indicates clearly the presence of the sign. Typographic signs were either in English or Japanese/English. Thanks to the clear, custom-made pictograms, however, text was not always necessary.

<<<

OSSO MINAMISUNA 207

A simple three-color palette was picked to make the sign system as clear as possible but still "float" in the background. The style of the pictograms closely resembles illustration but still maintains clarity and immediacy. Signs were either placed flat on vertical walls or juxtaposed on the side of entrances. This was achieved by means of polished metal slots in which the signs slide. This allowed more options for sign placement and added a three-dimensional feel to the signage.

>>>

POOL LOUNGE
プールラウンジ

PARK TOWN 209

PARK TOWN

A degree show exhibition at Central Saint Martins College of Art & Design, The MA Creative Practice for Narrative Environments deals with spatial interventions, occurring largely in the public space. The show needed to reflect this communal dimension while allowing for a wide range and media of student work to be displayed. The design of the signage for Park Town followed a bold and colorful approach; complemented with rich textures such as orientated strandboard and glossy fluorescent vinyl, it contrasted with and balanced the largely green surroundings.

Location: London, United Kingdom
Design team: Transfer Studio
Website: www.transferstudio.co.uk
Main materials: screen-printed wood

>>>

The space became a meeting point and connecting hub that took on many of the characteristics of the public space it parodied, with visitors often taking ownership of the space. Each garden shed housed the projects of two students and inherited the function of their work. Audiovisual work was located in the cinema, the town hall displayed radical public design schemes and the launderette sheltered smaller community projects. The design scheme and materials pallet was continued in the exhibition catalog and additional exhibition structures.

All material for the project was of recycled nature, using thick composite wood with bright orange screen-printed, typographic signs. Pictograms were also designed to add a graphical dimension and were used both on the sheds and on the main exhibition catalog.

212 ROYAL MELBOURNE SHOWGROUNDS

ROYAL MELBOURNE SHOWGROUNDS

A wayfinding strategy to deal with multiple user groups and a difficult site was developed with a typography-color-form system to aid the show and nonshow modes of this dynamic environment. Challenges included creating one signage solution to operate across a variety of building types, from heritage-listed buildings to the new angular architectural form. The studio opted for a very rigorous solution, combining a strong color palette and both sans and serif fonts, giving a uniformity and longevity to the design and embracing the heterogeneous architecture.

Location: Melbourne, Australia
Design team: Soren Luckins, Adam Gibson/Büro North
Website: www.buronorth.com
Main materials: plastic, metal

>>>

214 ROYAL MELBOURNE SHOWGROUNDS

ROYAL MELBOURNE SHOWGROUNDS 215

On the front page one can appreciate Büro North's solution to embody maps in info-benches where the visitor can rest while consulting the map. After visitor flux studies, they were found to greatly aid the general wayfinding of the complex. Enamel plastic with aluminum posts provided the materials for vertical signage. The classic rectangular sign shape was replaced by a more modern half-arrow that comprised both typographical and standard pictogram solutions.

<<<

Lighting of the information posts ensured that the signage also served as aggregation points at night and during low-light conditions. Opposite page: Size does matter: in this vast complex, point sizes had to range from tiny to huge in order to be visible from far. The font's light relative weight was counterbalanced by the high readability of red versus black.

>>>

TRIENNALE BOVISA

In an effort to reevaluate the Bovisa industrial area, the city of Milan developed the Triennale Bovisa (TBVS) space for temporary exhibitions. The design studio developed the wayfinding system, a custom pictogram library representing all the facilities and amenities available at the center. Used by one of the most important art events in Italy, the Triennale di Milano, this project's main strength lies in its integrated banner and wall post system, an addition that extends the signage reach much farther than the building's walls.

Location: Milan, Italy
Design team: Silvia Amaduzzi, Tommaso Catalucci, Giorgio Caviglia/K12m
Website: www.k12m.it
Main materials: vinyl banners, metal panels

>>>

218 TRIENNALE BOVISA

01 | Lamppost banners

| Wayfinding system | Some applications | Graphics grid |

02 | Totem

| Dimension and different applications. | Exploded view of the totem at Piazza Bausan. |

03 | Time

| Totem | Lamppost banners | The wall |

04 | Map of the system

| Placing of the elements on the way to the Triennale Bovisa. |

> The signage system's main goal was to effectively and promptly display the activities of the event. The first step was the development of a custom library of icons depicting all of the facilities and amenities available at the center. K12m analyzed the changes of the surroundings on different levels. Through the years new architectural styles were added, and the demographics of the users changed from blue-collar workers to a mix of immigrants and students. The space was transformed from a quietly residential building and was given a fresh, artistic, cultural, and trendy image.
>
> <<<

TRIENNALE BOVISA 219

K12m implemented a fully customizable system through the use of totems and applied vinyl, maintaining a visual dialogue with preexisting elements. Totems are placed in strategic points where visitors converge—making the route to the TBVS a "city gallery." The overall graphic style is based on a tight and long rectangular module of varying lengths applied on different graphic elements and materials.

>>>

220 WATER POLICE PARK

WATER POLICE PARK

For over one hundred years the Water Police site around the Pyrmont peninsula was used for a variety of industrial purposes. After the restoration of the park was decided, the studio was called to find a suitable wayfinding solution that would integrate with the site's close relation to the ocean. Today, this vast city parkland site takes visitors down to the edge of Sydney Harbor. Throughout the park, the studio designed various items of signage and interpretive elements to visually guide visitors while simultaneously decorating the site.

Location: Sydney, Australia
Design team: Bruce Slorach, Emerson Wilshier, Maggie Tang/Deuce
Website: www.deucedesign.com.au
Main materials: wood, neon lighting, screen-printed laser-cut aluminum panels

>>>

On the first page, wooden elements and cyan lettering are shown. Wood is the primary element in this signage system and the cyan and silver of the lettering integrates perfectly with the marine context. The need to keep alive the original industrial purpose of the park brought designers to implement a "flotsam and jetsam" trail instead of the classic "history of the park" sign. The trail features cast metal figures and typography as though they have been washed onto the footpath like ocean debris.

WATER POLICE PARK 223

Other elements complete the simple yet effective scheme: vitreous signage panels, seating and decorative elements, a map in the ground plan. The enameled metal was laser engraved and coated with sea-salt-resistant paint. The decorative elements were individually placed in the concrete, adding some coarse debris found on site.

CUSTOM SIGNS

Customs signs make use of nonstandard pictorial design schemes to orientate visitors through public spaces. When instant recognition and spatial understandings are a must, custom signs are specially designed for the automatic reactions they trigger and for their superior legibility at a distance.

Post Office

DIY store

Dublin City
Baile Átha Cliath

Páirc a

DISPENSER

Agricultural Hall

Toilets in
Public Grandstand

Town Square

Wood Chop

RASV

DETAIL

A creatively led design and communications company, Detail is a relatively new but already well-respected studio in Ireland. They specialize in identity, print communications, and interactive design projects—large and small, simple and complex. The strategy focuses on analysis, simplicity, clear messages, and original output.

Paul McBride and Brian Nolan set up Detail after previously working as directors in larger studios. A conscious decision was made to form a small and flexible studio that could focus only on projects regarded interesting as and to collaborate with other specialists. Ultimately their goal was to strike an even balance between cultural and corporate work. There are currently five team members working from Smithfield, Dublin.

How did you become involved in the project? Did you work closely with the architects/interior designers?

We've been working with MCO Projects over the last number of years—originally developing their identity and then working in partnership with them on the communication design requirements of their projects. We were involved in Father Collins Park from the start in visualizing MCO's tender to Dublin City Council. Being successful in their bid, we were asked to work with them on the park identity and wayfinding.

What was the working relationship like between your company and other design companies on the project team?

Since we've worked with MCO for a number of years, we have a clear understanding of their requirements and processes. The project also required liaising with the signage manufacturers Omos and the printers AlphaDecal, which all ran smoothly.

Who is the client?

MCO were project managers and Abelleyro + Romero Architects (Argentina) were the architects, forming Ar. Arq. Ireland for the design and development of this landmark public park for Dublin City Council.

Did you develop the signage system around a unique concept or was it just a series of aesthetic choices?

MCO had chosen the monolithic system from Omos and we liked their clean lines and minimal structure, so we needed to come up with a graphic solution that complemented this but could also extend to the entrance signage concepts we developed.

What was your main source of inspiration for this project?

Because it was to be Ireland's first wholly sustainable park, we wanted to avoid clichéd eco styling in favor of something more sympathetic to the contemporary nature of the park's design and landscaping.

What kind of direction did you receive from the client in terms of the type of graphics/signage system they envisioned for the project?

They wanted a contemporary feel—something that would complement the scheme designed by MCO/Ar. Arq, but it was important that the park have its own identity reflecting the investment in one of the largest urban park redevelopment projects in Europe.

What would you say was the biggest challenge of the project?

The time scale was incredibly tight to produce the identity, stylized maps, icon suite, and all the elements needed to complete the project.

Did you follow the entire production yourselves? Did you commission work or did you install some parts yourselves?

MCO commissioned third-party suppliers while we followed each part of the project from proofing to end installation.

Tell us more about the typographic identity of the project.

Dublin City Council's identity guidelines specified the use of Helvetica. One of the challenges here was that all signage information had to be in dual languages, Irish and English, and they had to have equal prominence.

Did you also curate the print and Web communication for the project?

There was some promotional material for the park, explaining the sustainable nature of the park; providing information on the wind turbines, wetlands, and the ancient hedgerows; highlighting the benefits to the public; and indicating the playgrounds, public spaces, and fitness centers dotted around the park.

THE FUTURE OF SIGNAGE

As any discipline that thrives mostly on creative professionals, sign design has a very strong attitude toward renovating itself and engaging in experimentation. In this section we include projects that embrace this approach. Signage and wayfinding are here envisioned at large: any project that points to, indicates, or designates how to get from point A to point B, anything that gives information. Featured here are pioneering projects that make use of new materials or use them in unusual contexts or approaches. The case of Solar Roadways, for instance, could at first glance be seen as not pertaining to signage, but in fact this project is so revolutionary that it could turn the entire area of roadside signage design head over heels. The notion of a self-sustaining, energy-producing, self-cleaning, and self-updating road network could very well be one of the technological breakthroughs of this century. This can be seen as a clear indication of how experimental projects can be conjured up in one field but soon grow exponentially to affect "neighboring" disciplines, contaminating and redefining them to an extent not imaginable by its creators.

>>>

230 ALL THE TIME IN THE WORLD

ALL THE TIME IN THE WORLD

This Heathrow signage installation connects passengers between international terminals. The studio extended the notion of a world clock, commonly concentrating on capital cities in different time zones, by linking real time to places with exciting associations. Imagination is led to distant locations; the great natural wonders of the world, the highest mountains, the most beautiful lakes, the tallest buildings, the longest rivers, ancient cities, museums with untold treasures, dream islands, and exotic deserts. The sign thus points passengers to their destinations by means of the metaphor of time.

Location: London, United Kingdom
Design team: Troika
Website: www.troika.uk.com
Main materials: electroluminescent displays

>>>

232 ALL THE TIME IN THE WORLD

GMT, London's local time, forms the heart of the clock display, and any places west of London are situated to the left of the large clock, and equally, any places east of London are to its right. Troika developed a new typology of electroluminescent displays, which relies on a custom-designed segmented typeface (patent applied for). Apart from its incredible thinness (less than 0.2 inches), the display boosts high aesthetic impact and an extreme versatility in the characters displayed: up to five different fonts can be shown.

<<<

ALL THE TIME IN THE WORLD 233

The technique is transferable to other emerging technology such as OLED or E-paper. This is the first time that a display system of this kind has been implemented worldwide. Based on a vectorial design, its advantages are all the more noticeable in large scale (like here) or very small. It can also be curved, and is extremely competitive compared to other display technologies such as LED if text only is required.

>>>

CENTRE NATIONAL D'ÉTUDES SPATIALES (CNES)

The project comprised architectural design and a new identity for the entrance, reception, and exhibition areas. The goal was to communicate the complex technical research conducted at the Launcher Head Office of the French National Space Agency as well as its vision of the future, combining science and imagination into a "transition space." Beyond usual CNES Cosmos representation and functionalism expected of interior space, the studio wanted to question what transcends, widens, or contradicts their graspable reality, aiming to endow space atmosphere and sensory potential.

Location: Paris, France
Design team: Studio Daniela Bianka
Website: www.danielabianka.com
Main materials: vinyl, glass

>>>

CENTRE NATIONAL D'ÉTUDES SPATIALES (CNES) 235

The ground plan is developed from the building's peripheral vision. Boundaries interact with the inner space to guide staff and visitors. This is achieved through the facade: by several superimposed printed layers integrated into pivoting glass elements. A representation of the moon's craters shows the exceptional amount of detail. The conceptual lines relate to the matter of rocket research, or to "antithetical reflection" on near-space being-in-the-world where form is only an instant of a transition.

ERBA VALENCE

This project consisted in the completion of a "floating" sign for the school building of the Valence School of Fine Art (ERBA). The structure itself created a problem of placement for any standard signage solution. Lacking a direct front wall, a sign would have had to be either vertical or hung from the ceiling. Using anamorphic principle was the perfect solution. With an exceptionally low budget, the actual drawing of the sign was completely done in chalk by the students.

Location: Valence, France
Design team: Gaitana Valbuena/Reynald Philippe
Website: www.reynaldphilippe.com
Main materials: chalk

>>>

The anamorphic sign was intended to be readable from different directions. Even applying the chalk as uniformly as possible, the texture resulted in a sort of "superimposed" effect from afar. Moreover, the anamorphosis permits the interplay between the signage and the end-users, as it can be perceived differently depending on the angle from which it is seen. The chalk debris at the foot of the wall is part of the sign's identity, and cleaning staff were instructed to leave it untouched.

>>>

INDEMANN

Several townships were relocated in order to excavate the mineral resources from an historical open cast coal mine. Upon the decision to reconvert to a recreational area, the municipality wanted to erect a watchtower to mark this location. The studio decided on using the shape of an immense, 120-foot-tall robot: the Indemann. The front has had forty thousand LEDs incorporated into it. This is the first LED façade to be implemented on this scale in Europe and it works like a folded screen and can have animations projected onto it.

Location: Inden, Germany
Design team: Maurer
Website: www.maurerunited.com
Main materials: GKD Mediamesh®

>>>

Mediamesh, a joint development between ag4 media façade and GKD, is a revolutionary new product that integrates digital imagery and color with metal fabric. Special LED strips are woven at regular intervals into GKD's stainless-steel mesh. Different variations of the thousands of LEDs make Indemann a massive landmark and sign visible from a range of miles. The public experiences the building as a composition of architectonic experiments, in the outstretched robot arm sixty feet above the ground.

>>>

KPN TOWER

A semitransparent curtain wall supports a 40,000-square-foot grid containing 896 evenly spaced, independently steered lights. It projects preprogrammed graphics and animated effects a distance of up to 1.2 miles. To safeguard the essential dynamism of this communication solution, a script has been devised—a graphic choreography of sorts—that successively alternates moving and static configurations, thereby heightening the effect of both. The system was initially developed as an essential part of the architecture but it can also be used to advertise events and create custom messages for the city of Rotterdam.

Location: Rotterdam, Netherlands
Design team: Studio Dumbar
Website: www.studiodumbar.com
Main materials: lights

>>>

KPN TOWER 241

The KPN Tower is already a civic landmark. Its silhouette dominates the Rotterdam skyline and moving letter art types. The project was honored with the prestigious international Red Dot Best of the Best Award for public areas. Nonetheless, not everyone has been charmed. The neighborhood demanded the blackout period be extended by two hours. The building now sleeps between 11 p.m. and 7 a.m.

242 LEIDSCHE RIJN

LEIDSCHE RIJN

Twenty-five works of art and dozens of shows were the main attractions at the first edition of this multifaceted culture festival. The typographic signage routing was needed to indicate all the artworks. An exceptionally clear and visible signage was needed to balance the size of the exhibit site and its unfamiliarity to visitors. Autobahn presented architectural typographic objects, laser-cut out of sustainable polystyrene. Besides the typographic route, the studio designed several other wayfinding parts including the program booklet, floor and bicycle maps, and banners.

Location: Utrecht, Netherlands
Design team: Autobahn
Website: www.autobahn.nl
Main materials: plastic laser-cut elements, metal pins and straps

Laser-cut polystyrene, white and orange is the perfect medium, cheap and easy to install and carry and recyclable. The signage system is conceived to attract attention as an active element in the landscape; this is achieved by big dimensions and three-dimensionality.
The big white numbers with their immediately recognizable form aid visitors in their tour of the vast art park. To prevent wind from displacing them, the numbers were fixed on the ground by means of nails. After the event, the objects will be collected and recycled.

>>>

NEAREST METRO IPHONE APP

Augmented reality is currently the hottest trend in virtual signage and wayfinding. Essentially it is a real-time dynamic graphical interface. The concept is to enhance the image in the video device with all kinds of information useful to the end-user. One of the first augmented reality apps to go live in the iPhone AppStore was Nearest Metro. This application tells the user where his/her nearest subway station is via the iPhone's video function, combined with GPS. This is just the first of many applications that will surely revolutionize the way we conceive wayfinding.

Location: virtual
Design team: Acrossair
Website: www.acrossair.com
Main materials: virtual

>>>

NEAREST METRO IPHONE APP 247

This app is conceivable as a handheld signage system that self-updates and self-references. Holding the phone flat, all metro lines are displayed in colored arrows. By tilting the phone upward, nearest stations are shown: what direction they are in relation to the phone's location, how many miles away they are, and what tube lines they are on. If you continue to tilt the phone upward, you will see stations farther away, as stacked icons. While conceptually simple, it opens the road to many other augmented-reality applications.

>>>

248 NEW MUSEUM

BOWERY ELECTRIC CAFÉ
Sunny and Brad Goldberg

FREIGHT ELEVATOR

STAIRWELL

NEW MUSEUM

The inspiration for this project came from the idea of "new" in the building's name: new materials, unconventional approaches, and the museum's very original structure. Echoing the museum's architecture, signage continues onto the floor surfaces to define discrete three-dimensional spaces. This is done by means of a revolutionary electrified PVC material that was initially deployed in advertising and other commercial activities. It is here used to surround the user with information and to re-create a virtual environment in the physical space.

Location: New York, N.Y., United States
Design team: Joshua Distler
Website: www.joshuadistler.com
Main materials: EL-vinyl

>>>

250 NEW MUSEUM

The EL concept draws its design inspiration from the use of EL-Vinyl, a type of vinyl that can be powered with low voltage to glow. The cubes concept is based on the architecture of the museum; the building appears to be an arrangement of stacked cube forms rather than one single, solid object. Both signage system concepts relate to elements that make the museum itself unique.

<<<

Typography was based on the New Museum's corporate font and use was primarily driven by how the signage was produced. In the EL concept, the type was to be cut out of solid shapes and therefore the aim was to stack the type in a block (much like in the corporate identity itself). In the cubes concept type is used sparingly and in conjunction with a system of icons.

>>>

SOLAR ROADWAYS

Calling this project revolutionary would be an understatement. The Solar Roadways is a series of structurally engineered solar panels that are driven upon. The idea is to replace all current petroleum-based asphalt roads. Signage-wise, this new technology is a true innovation. Its implementation would turn obsolete at once our current system of horizontal and vertical street signage. LEDs would light up the entire road, making it, in practice, one virtually infinite dynamical and self-updating sign system.

Location: n/a
Design team: Scott and Julie Brusaw
Website: www.solarroadways.com
Main materials: solar panels

>>>

SOLAR ROADWAYS 253

The roads would be composed of three layers. The Road Surface Layer, translucent and high-strength, is rough enough to provide great traction yet still passes sunlight through to the solar collector cells. The Electronics Layer contains a large array of cells, the bulk of which will contain solar collecting cells with LEDs for "painting" the road surface. While the Electronics Layer collects and stores energy, it is the Base Plate Layer that distributes power and data signals (phone, TV, Internet, etc.).

STUDIO DANIELA BIANKA

Studio Daniela Bianka works across the full spectrum of identity scenario design: exhibition, event, scenic, graphic, visual, and architectural design. This enables them to address a broad range of projects from institutional to brand design development and commercial architecture. The multidisciplinary team is made up of a visual artist/designer, an architect, a graphic designer, and a set designer. The studio approach focuses on the hybridization of design, communication, and arts disciplines. The interweaving of visual arts and architectural and stage design helps develop a global perspective of space and of surfaces with an integrated conception of both a poetic and a rigorous approach. The idea is creating an identity, which can be a poetical discipline and a cultural service to society.

Tell us about your the challenges that drive you.

I'd like to start with two citations.
We aim at bringing about singular and innovative solutions into the complexity and elegance expected of a space, that is, expressions of corporate and visual identity. This means full understanding of all design issues, responses to multiple functions, respect of constraints, responses to user-focused approach and to human vision.
Each project should enable the user to inhabit a space, to experience the space, to be fully integrated into its subjective and singular "landscape." By transferring rhythm, action, and mutation into abstract landscapes we aim at creating a "network within a situation" wherein the human being finds its bearings. Our goal is to foster a "sensitive mobile design" rather than "fixed and definitive forms, spaces and time."
To create a coherent space today it is incontrovertible that we are also focused on sustainability in our design processes in order to produce more sustainable solutions (to reduce, to recycle, to reuse, to restore). Designers have an unprecedented opportunity to use skills to make meaningful, sustainable change.

What are your main sources of inspiration? What past designers/studios do you refer the most to?

Our design process is nurtured by the singular balancing of tensions between functionality and fragility, rationality and emotion, structure and fluidity, micro and macro, intimate and distant, otherness and shared ... During the conception process, the emphasis is on joyful interactivity, on getting lost, on provoking the unpredictable.

Personal inspiration:

I always come back to old and new philosophy. Authors such as Henri Bergson, Nietzsche, Spinoza, Lévinas, Baudrillard and Roland Barthes, Valery, Eluard, Aragon, Sloterdijk, Finkielkraut, Virilio …
Our inspiration in the studio concerning past graphic identity starts with cubism—Cassandre, Charles Loupot, Savignac, and German/Swiss graphic history. Lately, inspiration might come from strolling in the Parisian Barbès quarter …

What kind of brief do you usually receive from the client? Do you work with specific directions, or do you enjoy freer terms of work?

We enjoy working on global projects with an intense dialogue with the client. Usually it gets us a more open vision. To achieve best results one has to get everybody involved as early as possible. I feel I have to create constant communication between the teams and try to adopt a common language.

Do you follow the entire production by yourselves? Did you commission work or install some parts yourselves?

To optimize results we actively coordinate and monitor the production process until completion. Each project means interaction and cooperation with industry and craft, high and low tech, tradition and contemporary techniques. We partner with master artisans and manufacturers to produce pieces with metal, concrete, resin, fiberglass, tadelakt, wood, glass, and textiles. Collaboration with them is fundamental to explore new techniques.

Where do you think the future of wayfinding lies? New technologies?

Recently, we were thinking about the relationship between online navigation and offline wayfinding. The digital and the real world should always be allowed to interact. Perhaps the biggest challenge is to be simple, elegant in such complexity. We take into consideration the interaction of Web communication in all our new projects.

Will it be a "luxury" to experience the feeling of getting lost? And isn't there some joy in getting lost and strolling around? Will the real world become clickable?

Being lost has been part of human perception for such a long time. The future will be fast and slow, here and there, with its interaction of continuity and interruption. Are we going toward a well-informed mass of "nonconsumers"? Perhaps new technologies will give us an opportunity to shape a more equitable world.

Photo Credits

Manchester Art Gallery—© Phil Sayer
Spertus Institute—© Tim Wilson, William Zbaren (façade photo)
Tate Modern—© Victoria Blackie
Kreissparkasse Ludwigsburg—© Michael Heinrich
Kantonsschule Oerlikon—© Arazebra, Zurich & bivgrafik
Gemeindeverwaltungszentrum Affoltern am Albis—© Huberlendorff Fotografie
Photographs of the production process—© Bringolf Irion Vögeli GmbH
Militärakademie an der ETH Zürich—© Walter Mair
Photographs of the production process—© Bringolf Irion Vögeli GmbH
All The Time In The World—© Alex Delfanne/Artwise Curators 2008
KPN Tower—© Sybolt Voeten
Solar Roadways—© Dan Walden

Unless otherwise stated above, photo credits on page belong to respective studios.